MW01056922

The College History Series

160 YEARS OF

SAMFORD UNIVERSITY

FOR GOD, FOR LEARNING, FOREVER

The College History Series

160 Years of

SAMFORD UNIVERSITY

For God, For Learning, Forever

Sean Flynt

ARCADIA

Copyright © 2001 by Sean Flynt.
ISBN 0-7385-1353-9

Published by Arcadia Publishing,
an imprint of Tempus Publishing, Inc.
2 Cumberland Street
Charleston, SC 29401

Printed in Great Britain.

Library of Congress Catalog Card Number: 2001088814

For all general information contact Arcadia Publishing at
Telephone 843-853-2070
Fax 843-853-0044
E-Mail sales@arcadiapublishing.com

For customer service and orders:
Toll-Free 1-888-313-2665

Visit us on the internet at http://www.arcadiapublishing.com

CONTENTS

ACKNOWLEDGMENTS

This book would not exist without the Samford University Library in general and the library's outstanding Special Collection Department in particular. I am especially indebted to Special Collection staff members Elizabeth Wells, Becky Strickland, and Jennifer Taylor, who helped answer my countless "who, what, where, when, why" questions.

They, in turn, depend on the generosity of alumni who donate historic items in an astonishing variety of forms, including letters, scrapbooks, memoirs, clothing, and even needlework, just to name a few. And then there are the photographs—the priceless amateur and professional records of Samford's history.

As important as the photographs are by themselves, they can't be divorced from the stories they illustrate. Information for captions came from the *Crimson*, *Entre Nous*, *Seasons*, and especially from the writings of Mitchell Bennett Garrett and James F. Sulzby Jr. I happily acknowledge my debt to all the writers and photographers who preserved Samford's history in ink and silver.

REFERENCES

Garrett, Mitchell Bennett. *Sixty Years of Howard College, 1842–1902.* Birmingham, Alabama: Samford University, 1927.

Sulzby, James F. Jr. *Toward a History of Samford University.* Birmingham, Alabama: Samford University Press, 1986.

NOTE: Individuals in photographs are identified from left to right only where indicated.

INTRODUCTION

Baptists began to shape education in Alabama before the state was fully formed. Their vision extended even into the heart of the Creek Indian Nation, where Baptist missionaries struggled to maintain a residential manual labor institute for Creek children. In the early 1830s, the director of that evangelical experiment was among those promoting the creation of a similar, self-sustaining farm/school to serve Baptist students, especially prospective ministers. By 1836 the Alabama Baptist Convention had such a school, an ill-fated manual labor institute at Greensboro. It failed to meet either the financial or educational expectations of its founders and soon closed.

With the lessons of the failed Greensboro school still fresh on their minds, a group of Baptists turned to Marion, a wealthy city of 1,200 near the heart of Alabama's antebellum cotton and slave economy. In 1841, without explicit convention approval, they established there a new school and began a remarkable institutional odyssey. Named Howard College in honor of English prison reformer John Howard, the institution would survive fires, wars, relocations, financial and cultural upheaval, and renaming to become one of the region's top universities.

Howard College took root in Marion, but suffered greatly from the Civil War and its tumultuous aftermath. Declining enrollments, bankruptcy, and the humiliation of the forced auction of the campus on the steps of the Perry County courthouse led Howard officials to a difficult decision. Boosters from Birmingham, Marion's new industrial neighbor to the north, offered generous incentives for the college's relocation to the East Lake community near the booming city. And so, though hurtful to those in Marion who had for so long supported Howard, the college accepted Birmingham's offer and moved to East Lake in 1887.

Unfortunately, Birmingham's economic bubble burst just as Howard College settled into its new home. Visions of a rich endowment and grand new facilities were soon put away, prompting one former supporter of the relocation to proclaim, "Well, if I had known that we were not to have buildings, I should never have voted for removal." Historian Mitchell Bennett Garrett paints a vivid and unflattering picture of the campus in those early years in East Lake.

> *At the college, the scene was anything but inviting. Two wooden buildings of hasty construction stood wide apart in a growth of old field pines. The surroundings were uncleared of underbrush, and the trees which had been felled more than a year*

before to make room for the buildings were still lying about the grounds. The remnants of the library were scattered and torn over the floor of an outhouse; pictures and broken furniture were piled in the corners of the limited hall ways; the furniture of all the departments was old and rickety, the bedding inferior and worn.

By 1889 college officials had so tired of Birmingham's failure to provide all it had promised that they openly investigated abandoning East Lake. But optimism and local support returned and the college slowly improved its facilities and financial position.

Until the 1890s Howard College's student population was exclusively male. Between the 1870s and early 1910s it was also under rigid military discipline. But the enrollment of Anna Judge and Eugenia Weatherly in 1894 signaled the beginning of a new era at Howard. Although this initial experiment was short lived, supporters of coeducation persisted and Howard College permanently opened its doors to female students in 1913—the same year it abandoned its military program.

Howard continued to grow but economic depression and war eventually threatened to ruin the school as they had ruined so many other colleges in the 1930s and 1940s. Howard president Harwell Goodwin Davis sought ways to insulate the school from hard times. During World War II he actively lobbied for and won a contract with the federal government to host a branch of the U.S. Navy's V-12 training program. The Navy brought Howard money and men at a time when both were in short supply at the college. The money, in particular, would have far-reaching effects on Howard. Davis saved enough of the V-12 funds to allow Howard to leave behind the campus that was never all it had promised to be.

Post-war enrollment increased thanks in part to the GI Bill, making relocation of the college ever more appealing. By the late 1940s Howard's leaders had selected a site for a spacious new campus in Shades Valley, just south of Birmingham. The college relocated to its final home in 1957 as Davis's ambitious vision of an architecturally uniform Georgian-Colonial campus slowly took shape.

Completion of the originally planned campus fell to Davis's successor, Leslie S. Wright. Growth during the Wright years was not limited to bricks and mortar, however. In 1965 Howard was elevated to university status, taking the name Samford University in part to avoid confusion with Howard University and in part to honor the family of longtime trustee Frank Park Samford. Throughout the 1960s and 1970s new schools and programs dramatically expanded Samford's educational offerings.

Current president Thomas E. Corts took office in 1983 and fueled Samford's remarkable growth. Under his leadership, the university has earned a place among the South's top five regional universities; posted record enrollments; established a London Study Centre and expanded other international study opportunities; undertaken at least a half-dozen major building projects; and nurtured an endowment of over $300 million—among the top five percent of all of the nation's universities and colleges. This recent success owes much to the remarkable generosity of the Beeson family. For over three decades the Beesons have helped define both the physical and intellectual shape of Samford University, which today consists of the Howard College of Arts and Sciences, School of Business, Orlean Bullard Beeson School of Education and Professional Studies, School of Performing Arts, Ida V. Moffett School of Nursing, McWhorter School of Pharmacy, Beeson School of Divinity, and Cumberland School of Law. In terms of facilities, intellectual scope, and success, the university seems far removed from its origins. But the images presented in this book remind us that Samford's present flows directly out of the hope and work of past generations.

One

THE MARION YEARS

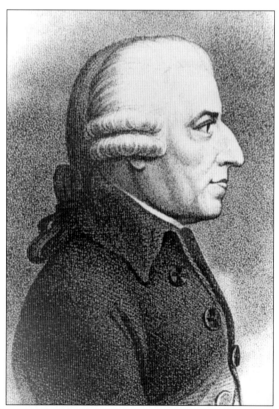

JOHN HOWARD, 1726–1790. Howard College, established in 1841 in Marion, Alabama, took its name from this Englishman noted for his humane and progressive attempts to reform the prison systems of his own and other countries. Samford University's Howard College of Arts and Sciences preserves the reformer's "ideals of educated, selfless Christian dedication to serving even 'the least of these,'" writes recent college dean Roderick Davis.

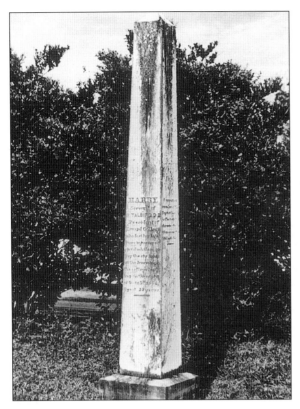

MONUMENT TO HARRY. Harry, a slave owned by Pres. Henry Talbird, died while saving Howard students from the devastating fire of October 15, 1854. Thanks to his courage, all but one survived. As for the college, "all was lost save faith in God and love for His cause." Grateful survivors and other state Baptists erected the memorial to Harry in Marion's public cemetery and quickly set about rebuilding the college.

SAMUEL STERLING SHERMAN, HOWARD COLLEGE PRESIDENT, 1842–1852. By the end of its first season, the new Baptist college in Marion, Alabama, had attracted only 31 students, whose tuition was not sufficient even to pay for 27-year-old President Sherman's board. The Vermont-born educator persisted in acquiring both students and supplies, at one point going so far as to push a wheelbarrow from door to door in Marion seeking donations of books for the college library. In the 160 years since, 16 other presidents have dedicated themselves to the good of the institution. They include Henry Talbird, 1853–1863; Jabez Lamar Monroe Curry, 1865–1868; Samuel R. Freeman, 1869–1871; J.T. Murfee, 1871–1887; Benjamin Franklin Riley, 1888–1893; Arthur Watkins McGaha, 1893–1896; A.D. Smith, 1896–1897; Frank M. Roof, 1897–1902; Andrew Phillip Montague, 1902–1912; James Madison Shelburne, 1912–1917; Charles B. Williams, 1919–1921; John C. Dawson, 1921–1931; Thomas V. Neal, 1932–1939; Harwell G. Davis, 1939–1958; Leslie Stephen Wright, 1958–1983; and Thomas Edward Corts, 1983–present.

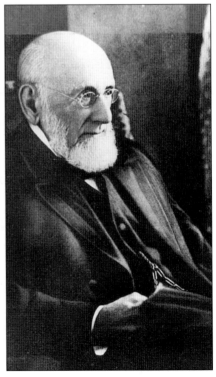

10

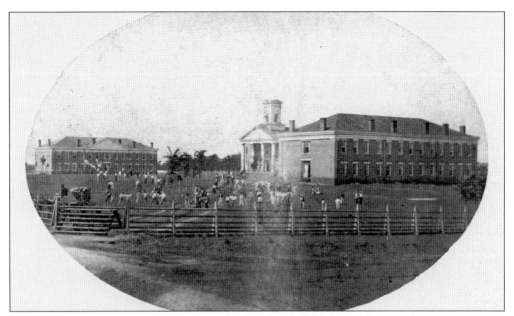

Earliest Known Photograph of Marion Campus, 1860s or Early 1870s. The Howard students pictured here were very much aware of the photographer's presence—many are posing with friends and others are staging mock fights. The main building complex, at center, contained a chapel, library, apparatus rooms, laboratory, lecture halls, and administrative offices. Two student dormitories (one is visible at far left) contained "recitation" rooms and a total of 44 student rooms, each 18 feet square. A bell rang at dawn to wake students and again at sunrise to begin an hour of study before breakfast.

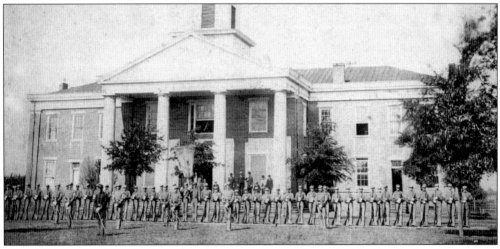

Howard College Cadets on the Marion Campus, 1870s or 1880s. Beginning in the early 1870s, Howard College president J.T. Murfee required students to wear gray, military-style uniforms on public occasions and any time they left the campus. Murfee originally required the student uniforms for the sake of "discipline and economy," but martial training increased over time. As military drill became part of the students' daily routine, the college even acquired a muzzle-loading cannon. An 1883 loading accident removed part of a careless cadet's arm. "Thereafter," writes Samford historian James F. Sulzby Jr., "the cannon was put to less use."

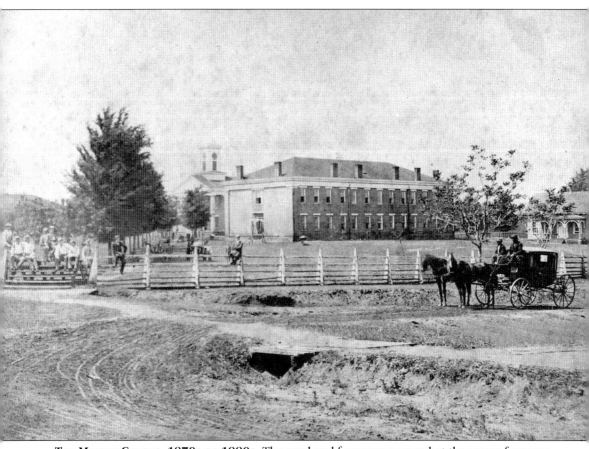

THE MARION CAMPUS, 1870s OR 1880s. The road and fence are somewhat the worse for wear in this image, but the college had by this time added the dining hall visible behind the carriage at far right. The "new and beautiful Italian cottage, conveniently located and handsomely furnished" was completed in the early 1870s.

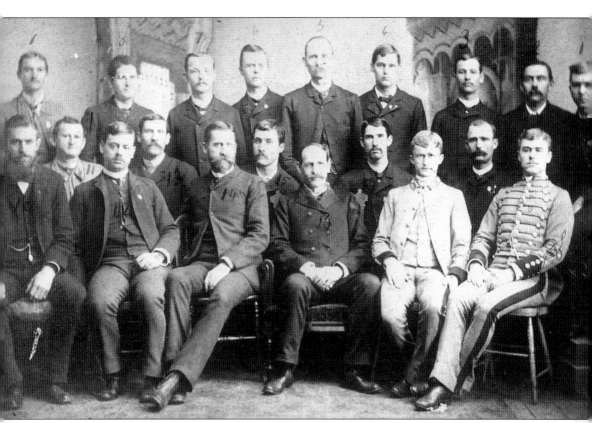

HOWARD COLLEGE STUDENTS AND FACULTY POSING TOGETHER, *C.* **1886.** The Howard College cadets seated at right display the student uniforms that were required wear for public events. At the time of this photograph the college offered uniforms of two different quality levels. Those pictured here may reflect that difference.

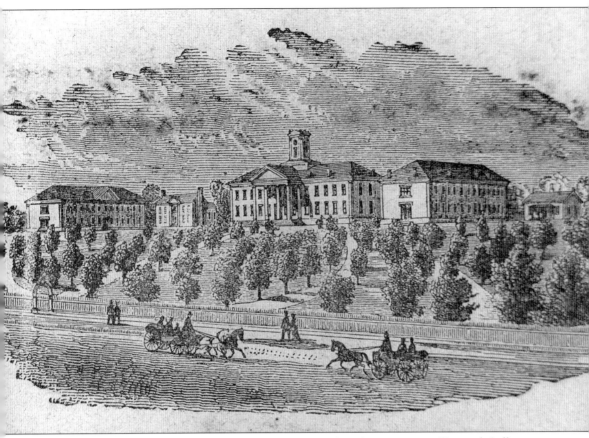

FRONT VIEW OF MARION CAMPUS, 1880S. Buggies and pedestrians pass Howard College on the large, well-finished avenue in front of the Marion campus. Today's view from Washington Street in Marion is strikingly similar because the site's second (and present) occupant, Marion Military Institute, preserved some of the architecture and general plan of Howard College. Though beautiful and once thriving, the town of Marion was out of the mainstream of the region's emerging post–Civil War economy and culture. It could not match the opportunity of Birmingham.

Two

A NEW VISION

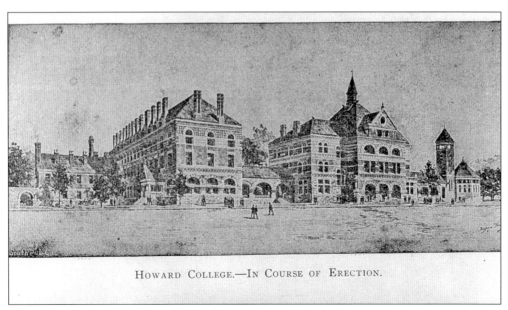

HOWARD COLLEGE.—IN COURSE OF ERECTION.

GRAND HOPES FOR HOWARD, *C.* **1889.** An artist's conception illustrates a campus that never was. Compare this view to the photograph of the campus in 1894 (see page 17). Only the Main Building (second from right) resulted from this plan, albeit in a slightly modified form.

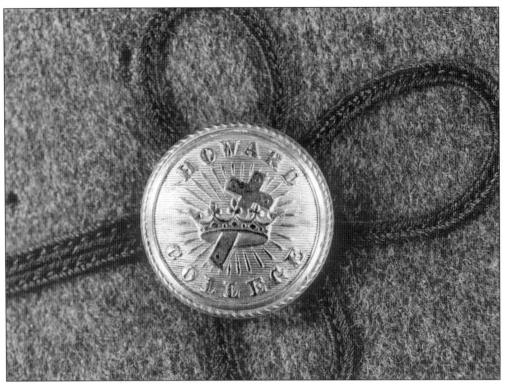

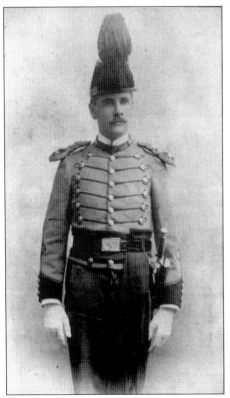

CADET UNIFORM BUTTON, LATE 19TH CENTURY. The Howard College cadet uniform preserved in Samford University's Special Collection Department illustrates President Murfee's description of the coatee's distinctive buttons. They "bear a most beautiful and suitable device—a cross and crown irradiating a halo of light and glory, with 'Howard College' in prominent letters around the buttons."

JOHN FRANCIS BLEDSOE IN HOWARD COLLEGE CADET UNIFORM, 1893. In President Murfee's estimation, the cadet uniform "is in elegant taste and adds wonderfully to the appearance of the young gentlemen." Samford University's Special Collection Department owns a coatee and trouser set of the elaborate style pictured here, which in its day could be purchased through the college for less than $19. Students of Bledsoe's era may have spent most of their waking hours in uniform. They were advised to bring from home only a good overcoat, rubber shoes, an umbrella, and "a good supply of underwear."

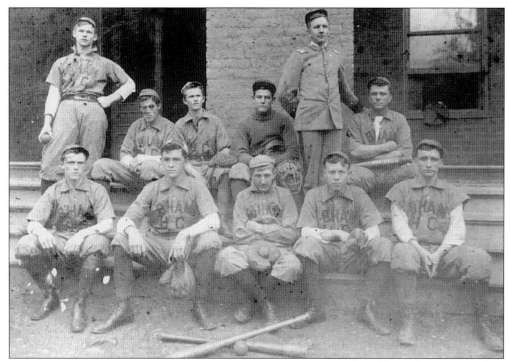

HOWARD COLLEGE BASEBALL TEAM, 1894. Baseball was played informally at Howard as early as 1872, though an 1878 victory over Southern University was the first official game on record. Howard student L.O. Dawson attributed the temporary decline of the sport in 1886 to the skyrocketing expense of college athletics. "A bat can't be had for less than six bits," he lamented.

EAST LAKE CAMPUS OF HOWARD COLLEGE, C. 1894. Like thousands of concerned parents to follow, J.J. Finklea accompanied his son to college in 1891. As the pair approached the campus on foot the father asked "My boy, how much farther? Are we not about at the place?" "Yes, Papa," his son replied, "this is the place." Finklea gazed about at the tangle of pines and brush before him and said, "but I didn't know, my boy, that you were camped here in the woods." By the time of this image, one of the earliest photographs of Howard College's East Lake campus, the lot had been improved somewhat. The Main Building at center was completed shortly before Finklea's visit. The famous Sherman Oak is seen at right. At bottom left a uniformed cadet stands with four women.

17

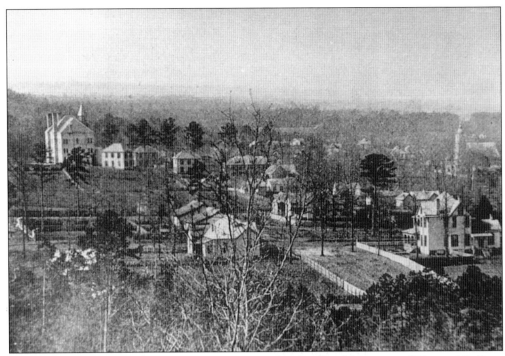

THE EAST LAKE COMMUNITY IN BIRMINGHAM, 1897. The decade-old campus of Howard College is visible at upper left in this aerial view of East Lake. The tallest campus building is Old Main. Although East Lake at the turn of the century appears almost suburban, only ten years earlier the campus needed a fence to exclude the free-ranging livestock of the still rural East Lake community.

ANNA JUDGE SCHOELLKOPF. Anna Judge, Class of 1896, is generally recognized as the first female graduate of Howard College. She later acted on the New York stage and became a talented amateur historian and author. Howard College admitted Judge and Eugenia Weatherly in 1894 as a first experiment in coeducation. The five young women enrolled in the following year were the last for some time due, in part, to a lack of adequate coeducational facilities.

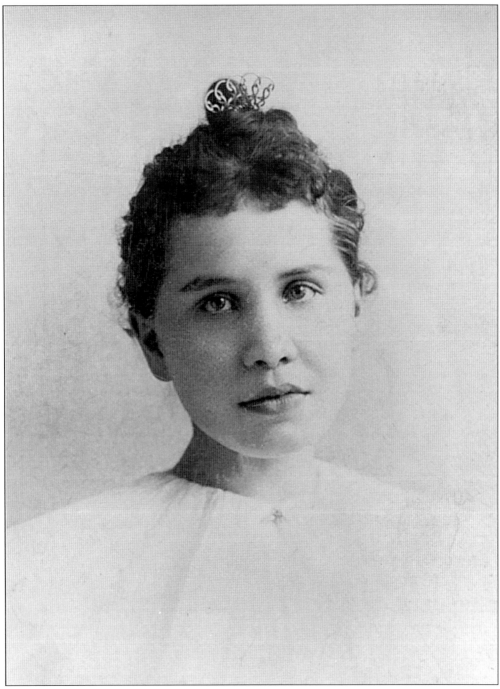

A. EUGENIA WEATHERLY KING. Eugenia Weatherly, Class of 1898, was the second female graduate of Howard College. Although the college officially and permanently opened its doors to female students in 1913, it still lacked residential facilities for women. The first group of "boarding" female students enrolled in 1920 and lived in Hendricks Hall, the home of a professor conveniently absent on sabbatical leave. Over a century later, in the fall of 2000, Samford University's female students outnumbered the males 2,581 to 1,789.

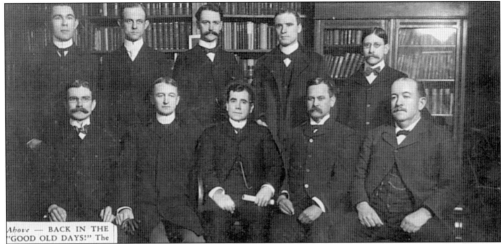

Above — BACK IN THE
'GOOD OLD DAYS!" The

HOWARD COLLEGE FACULTY, 1900. Pictured from left to right are (sitting) Edward Brand, James M. Shelburne, Frank M. Roof, C.C. Jones, and R.J. Waldrop; (standing) W.R. Hood, S.J. Ansley, E.H. Foster, E.P. Hogan, and Harry Miles. Howard's seven turn-of-the-century "schools" included Latin Language and Literature, Greek Language and Literature, English and Elocution, Modern Languages, Mathematics, Natural Sciences, and Mental and Moral Science.

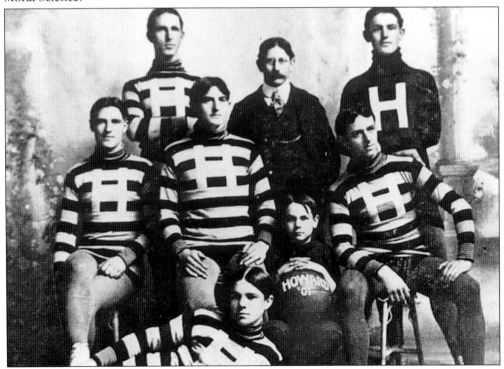

HOWARD COLLEGE'S FIRST BASKETBALL TEAM, 1901. Invented less than a decade earlier, basketball was greeted enthusiastically at Howard College, though with some confusion as to the specifics of play. According to the *Howard Collegian* of March 1900, information that each player would have "his own basket" must have been provided "by one, who, no doubt, was better acquainted with picking cotton than with this new game."

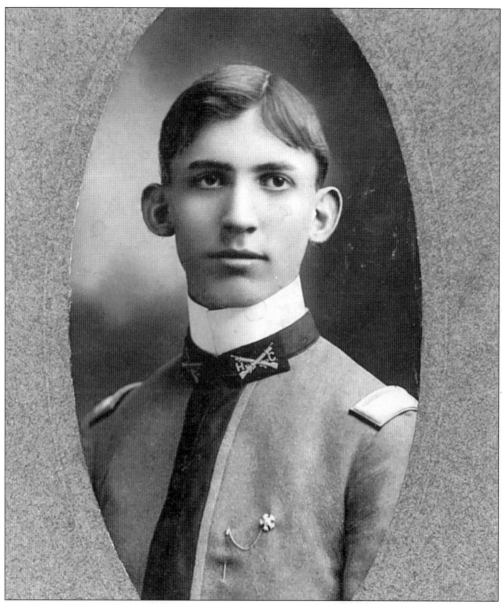

HOWARD COLLEGE CADET, EARLY 1900s. This portrait of an unidentified Howard student features a relatively plain cadet uniform bearing a Sigma Nu fraternity pin on its left breast. Samford's Greek tradition began with the 1856 formation of Howard College's Phi Gamma Delta chapter. That first Greek era ended with the Civil War. The fraternity represented in this image was organized at Howard in 1879 in defiance of President Murfee's 1876 prohibition against such organizations. The fraternity existed alone and underground for almost 15 years, eventually shielding its activities behind an elaborate front organization called The Sixteenth Infantry. Greek organizations thrived after Pres. Andrew Phillip Montague lifted the ban in 1902. Samford is currently home to seven fraternities and eight sororities, in which approximately 42 percent of undergraduates participate. Unlike their 19th-century forerunners, today's Greeks are fully engaged with Samford's mission, serving throughout campus and in the greater Birmingham community.

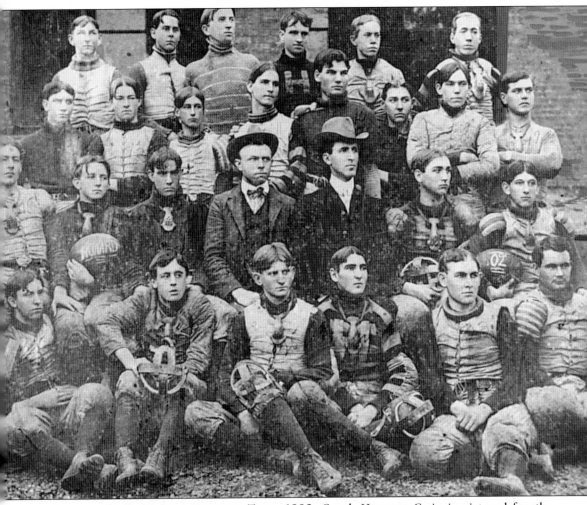

HOWARD COLLEGE'S FIRST FOOTBALL TEAM, 1902. Coach Houston Gwin is pictured fourth from left on the second row. Howard's first intercollegiate football game—a victory—was played against Marion Military Institute. Football has since been a highlight of student life at Howard College and Samford University, though the program was suspended during World War II and again in 1974. The sport's return in 1984 marked the beginning of a new era of Bulldog football—an era that so far has included rising to NCAA I-AA status and posting of Samford's best-ever football season.

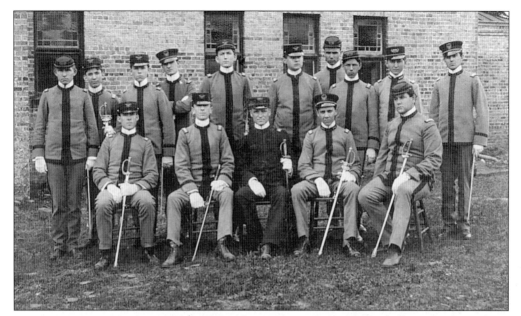

HOWARD COLLEGE CADETS, 1904. The military atmosphere of the college seems to have relaxed somewhat during the presidency of Andrew Phillip Montague (1902–1912). The graduates of 1903 were the first to wear civilian clothes for their graduation photograph, but commencement exercises continued to feature military "prize drills" judged by local veterans of the Spanish-American War.

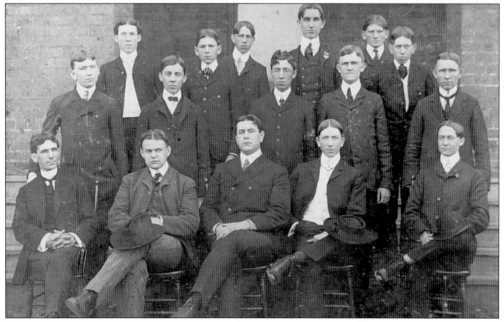

HOWARD COLLEGE GRADUATING CLASS, c. 1904. Some of the graduates pictured here seem to be the same young men in the 1904 photograph above. Howard's 1903 graduates posed for their class photograph in civilian clothes. These fellows "followed suit" in visually distinguishing between the military and civilian aspects of their education. The class of 1904 included Percy Pratt Burns, later dean of Howard College.

23

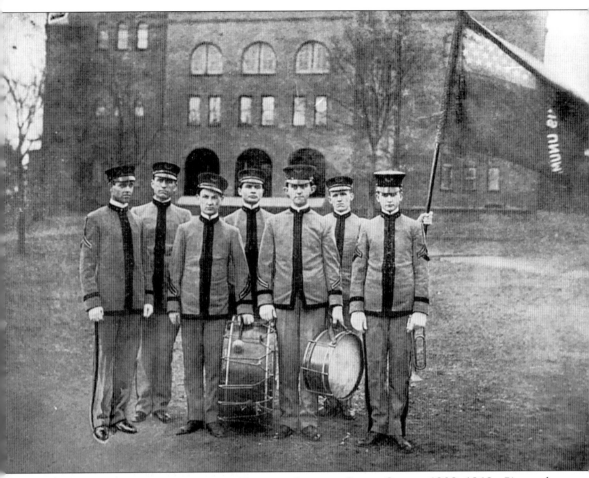

Non-Commissioned Officers of Howard College Cadet Corps, 1909–1910. Pictured in front of Old Main are C.H. Griffin, J.M. Rogers, M.V. White, H.H. Bacon, R.K. Hood, R.D. Cameron, and Q.J. Neighbors. Howard College abandoned its military curriculum in 1913, but wars both hot and cold would bring the U.S. military back to the institution from time to time.

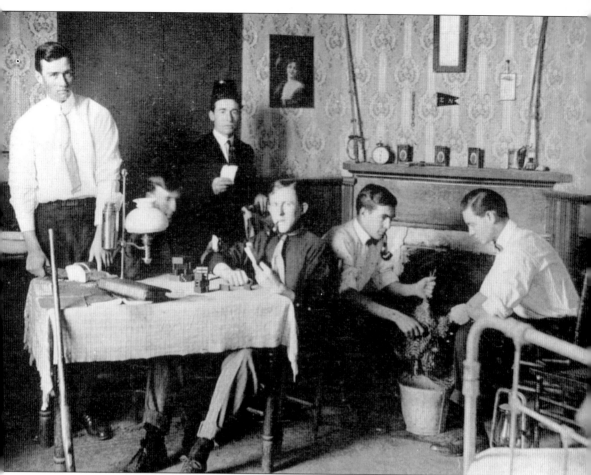

"A Midnight Scene in Paradise," **1910–1911.** Members of Howard College's Paradise Club offer a fascinating, if tongue-in-cheek, view of student life on the early East Lake campus. Shown are "Nifty" Craddock, "Wiz" Hagood, "Big Henry" Walker, "Slick" Tisdale, "Bob" Riley, and "Mushrat" Isbell. The official club yell was "Os-Key-Wow-Wow, Whiskey-Wee-Wee, Paradise, Paradise!" Note the shotgun leaning against the table at left and the chicken plucking underway at right.

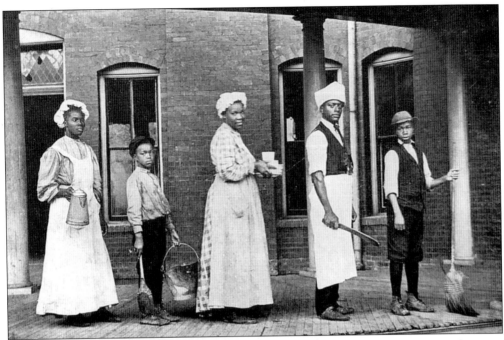

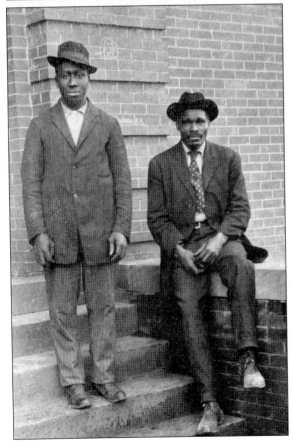

RARE IMAGES FROM EAST LAKE CAMPUS, 1909–1910. These remarkable portraits of Howard College staff, identified only as "Janitors" (left) and "Cooks" (above), were included among advertisements in the final pages of the 1909–1910 *Entre Nous* yearbook. The man at near left may be the "Janitor Green" identified in a later volume of the *Entre Nous*.

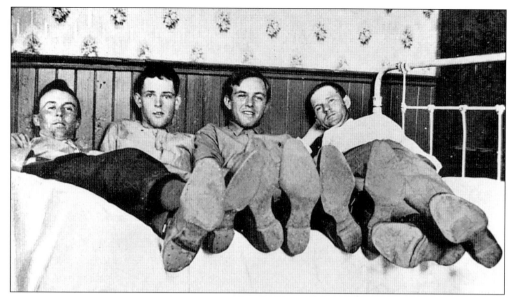

LOUNGING IN A DORMITORY ON THE EAST LAKE CAMPUS, 1909–1910. Members of the Honeymooners Club pose for "a typical scene during a.m. study hours." Club members are identified only as "Dearly Beloved" Montague, "Darling" Hendricks, "Uncle George" Macon, "Handsome" Dawson, and "Baby" Olive (one member may be behind the camera.) The names given here are almost certainly pseudonyms based on the college's faculty (President Andrew P. Montague, Dean George W. Macon, and professors John C. Dawson, James A. Hendricks, and Alfred H. Olive.) The club's favorite food? "Love Pudding."

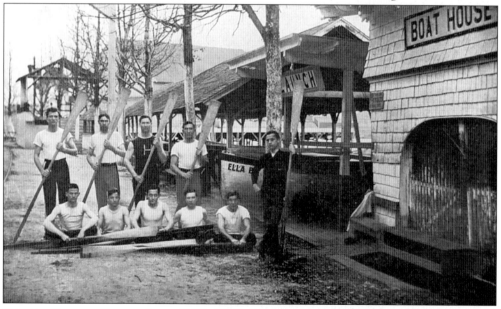

HOWARD COLLEGE ROWING CLUB, 1909–1910. Howard's second campus offered the unique sporting opportunity of East Lake. Club members included James Roy Hudnall, J. Pendelton Webb, Will W. Burns, Edd J. Berry, Julius H. Wright, Spurgeon R. Hutto, Drayton H. Doherty, John C. Watson, James D. Jackson, and Pink S. Jackson. Hudnall is related to Samford University benefactors Frank and Clara Hudnall

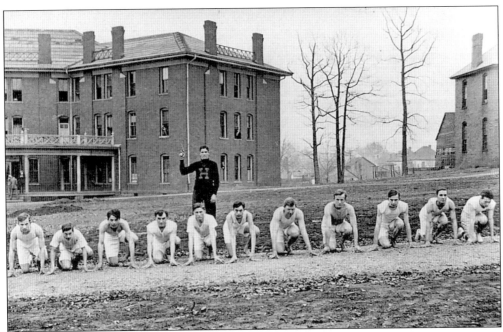

HOWARD COLLEGE TRACK TEAM, 1909–1910. Posing in front of Renfroe Hall on the East Lake campus are manager R.B. Kelly, W.C. Bentley, P.G. Compton, O.G. Forman, F. Gallant, C.B. Kingry, M.A. Hoffman, G.I. Dunsmore, H.H. Bacon, U.C. Bentley, H.B. Gilmer, and J.W. Gwin.

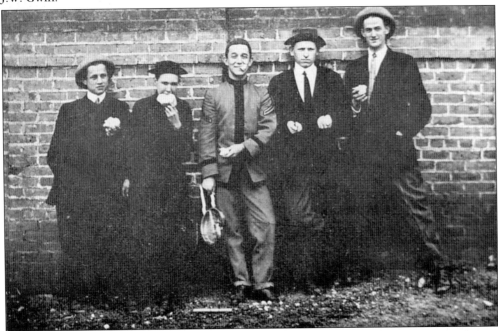

THE FIVE HUNGRY DEVILS, 1909–1910. The members of this unusual Howard student organization included "Chonny" Watson, "Runt" Burns, "Strong" Jackson, "Drayt" Doherty, and "Pat" Sessions. Note the frying pan held by the middle devil. Other dubious student organizations of this era included the Pie Club and the Disfigured Club.

28

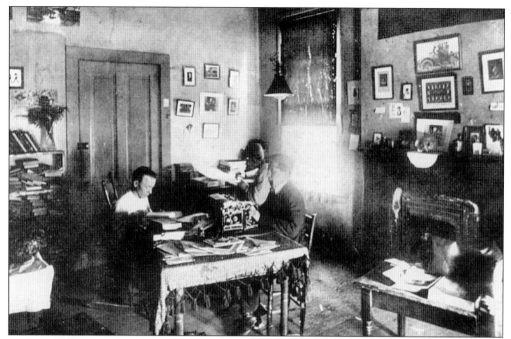

"EDITORIAL DEN" OF THE *ENTRE NOUS*, 1912–1913. First published in 1910, the *Entre Nous* (meaning "among us" or "between us") was, for over 80 years, the annual record of campus events, people, and places. Many of the images in this book are taken directly from the pages of the annual, which ceased publication in its traditional form in 1993, but continues as a much smaller, paper-bound volume.

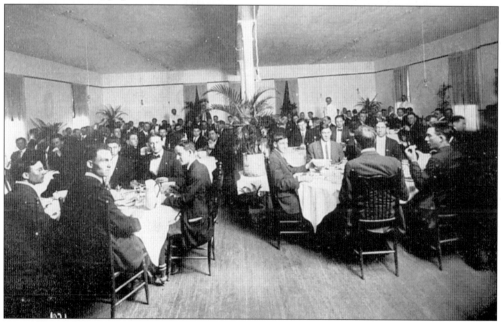

HOWARD COLLEGE DINING HALL, 1914. Today's cafeteria arrangements bear little resemblance to the relatively formal, restaurant-style dining of the college's early years. By 1919 the dining facilities in Renfroe Hall were entirely under student management.

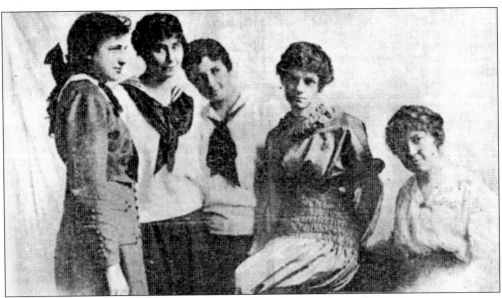

FIRST SORORITY, 1916. One of the earliest issues of the Howard College *Crimson* newspaper recorded the founders of Theta Xi, the college's first sorority. Seen from left to right are Cecilia Cain, Annie Merle Haggard, Hazel Newman, Frances Martin, and Kathleen Clark.

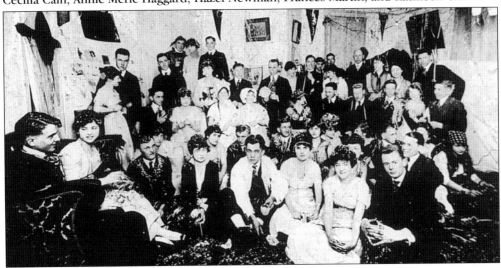

NOISEMAKERS: HOWARD COLLEGE'S FIRST CO-ED PARTY, 1916. A poem from the *Entre Nous* of 1914 is perhaps all the caption this image needs. The "Jimmy" referred to here is Pres. James Madison Shelbourne.

> *Once there was a prez named "Jimmy," in size not so tall nor skinny,*
> *and gray hair he had galore.*
> *Now this prez got into his head that Howard must be co-ed,*
> *and this idea we admit we adore.*
> *But what is bothering us is this prez raises a fuss*
> *when the co-eds mix too much with the boys.*
> *But, to be just, we guess we just must*
> *with the co-eds raise very little noise.*

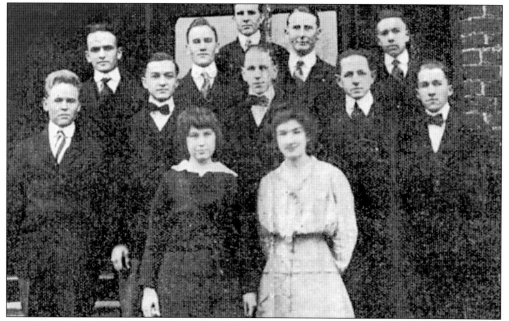

HOWARD'S FIRST JOURNALISM STUDENTS, 1916. In 1915 Howard College launched the *Crimson* student newspaper and offered the first journalism course available in the South Atlantic region. Demand for the course was so great the college had to create another and limit total enrollment in the two courses to only 20 students. Students in the upper-level class published the *Crimson* while the freshmen published the *Yellow Supplement* "to demonstrate what not to do in newspaper work." A disclaimer made it clear that stories appearing in the supplement were "based on things that are not and have not happened at Howard College."

STUDENT ARMY TRAINING CORPS (SATC), 1918. Howard College students got back into uniform when the United States entered World War I. Training options for SATC cadets included infantry, artillery, air, quartermaster, and chemical warfare services. First Lt. John H. Hill served as SATC camp commandant. In stark contrast to the college's military collaboration during World War II, the SATC wore out its welcome in the short time it existed at Howard. Pres. Charles B. Williams complained of the program's "blighting effects" and declared that "the military life at Howard was not conducive to intellectual, moral, or spiritual progress."

31

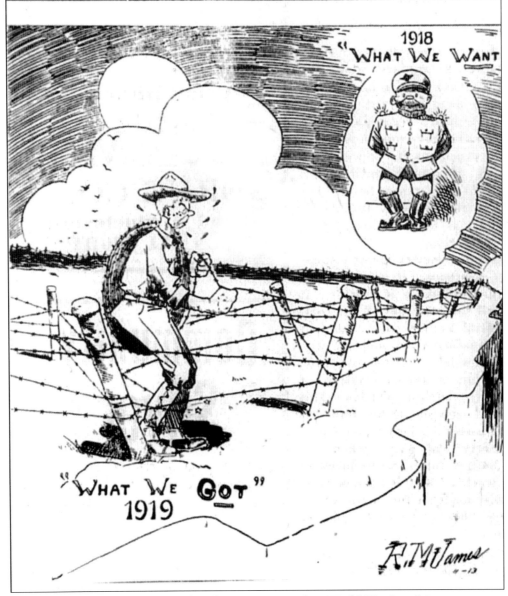

"WE WOUND IT ALL UP!" 1918. After the Armistice ending World War I, a *Crimson* cartoon lampooned the boast that SATC cadets would "wind up" the war. The cartoon noted that the cadets missed out on combat but might be just in time to wind-up miles of barbed wire along the former front lines. Howard's SATC cadets didn't get even that close to the war. They were demobilized in December 1918, only weeks after receiving their training rifles.

Three
THE GREATER HOWARD

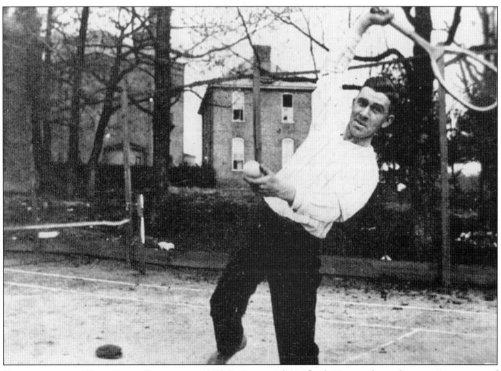

TENNIS ON THE EAST LAKE CAMPUS, *c.* 1920. An unidentified Howard student enjoys one of "three excellent courts, owned by three different fraternities, but being accessible to all students of the college." This image dates to just before the beginning of Howard's formal intercollegiate tennis matches.

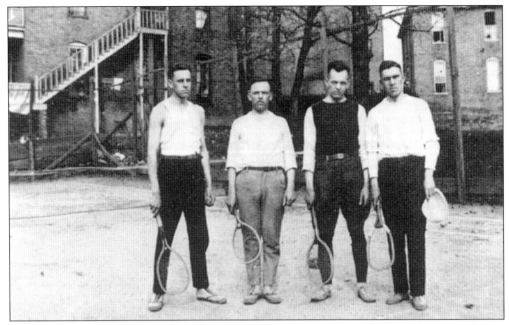

Tennis Courts and Campus Buildings, *c.* **1920.** A wider view of Howard tennis players reveals the state of campus facilities. The buildings visible here appear to be a bit run-down, as do the tennis players. Many of the facilities were makeshift and multipurpose.

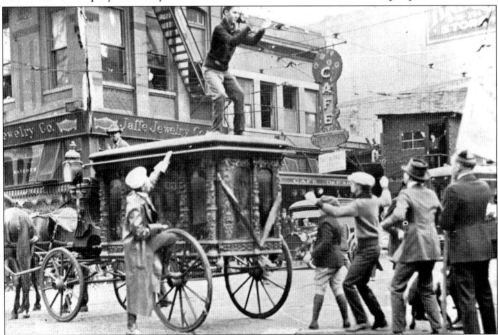

"Blockade On 19th Street," **1920–1921.** In this singular image, Howard College student Clarence Cox has mounted a horse-drawn hearse in an intersection of downtown Birmingham and is "leading his schoolmates in lusty cheers for their alma mater." The original *Crimson* caption notes that "the boys are responding with a magnificent disregard for the propriety of things," as a police officer prepares to end the show.

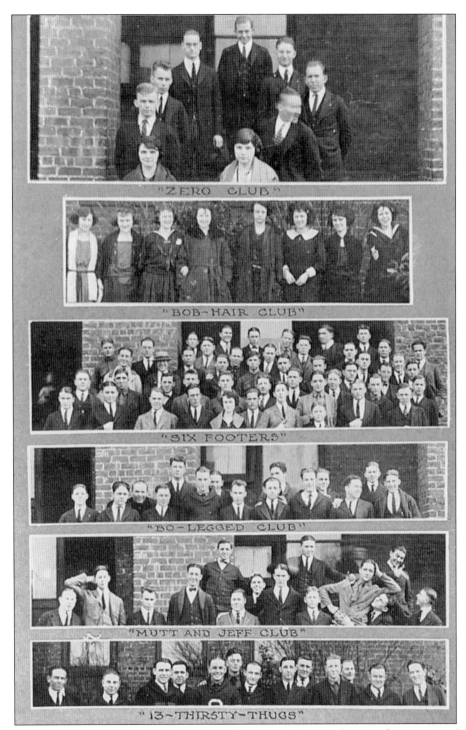

HOWARD COLLEGE CLUBS, 1921–1922. In the continuing tradition of tongue-in-cheek student organizations, here we have the members of the Zero Club, the Bob-Hair Club, the Six-Footers, the Bo-Legged Club, the Mutt and Jeff Club, and the 13 Thirsty Thugs.

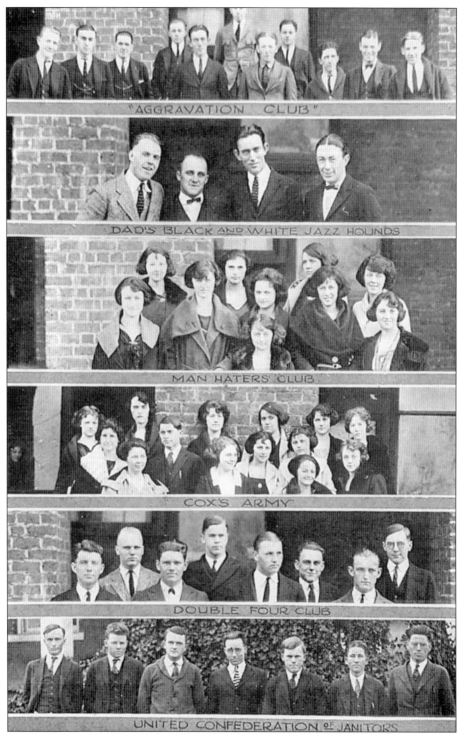

. . . AND MORE CLUBS, 1921–1922. More student organizations included the Aggravation Club, Dad's Black and White Jazz Hounds, the Man Haters Club, Cox's Army, the Double Four Club, and the United Confederation of Janitors.

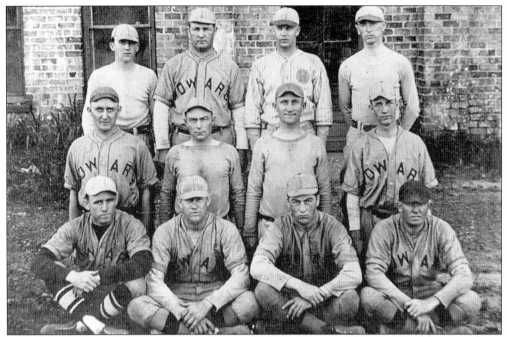

HOWARD COLLEGE VARSITY BASEBALL TEAM, 1921–1922. Team members included "Shorty" Webb, "Boilermaker" Alford, Dan Gaylord, "Papa" Garret, Jess Lackey, "Pat" Shores, J.B. Runyan, "Rowdy" Crews, Robert Shelton, R.C. Marshall, ? Ritenberry, and "Louse" Walker. The player second from the right in the middle row seems to be enjoying things a bit more than his teammates.

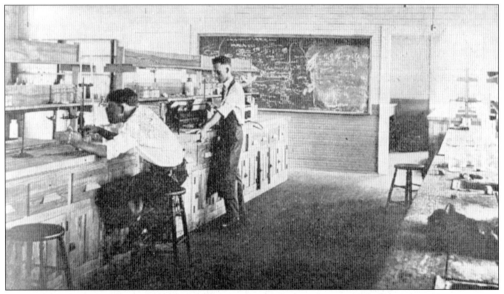

HOWARD COLLEGE CHEMISTRY LABORATORY, 1922. Although spacious, it seems to be lacking in certain modern laboratory conveniences. In the fall of 2001 Samford University will dedicate a new science facility containing the offices, classrooms, and laboratories of the Biology, Physics, and Chemistry Departments, as well as a 100-seat planetarium and a 2,000-square-foot glass-and-steel conservatory.

RENOVATION OF EAGLE'S FIELD, 1922. This rare early image of a common sight at Samford—campus improvement—was preserved in the pages of the *Crimson*. The athletic facility was renamed Berry Field in honor of Howard College benefactor W.A. Berry.

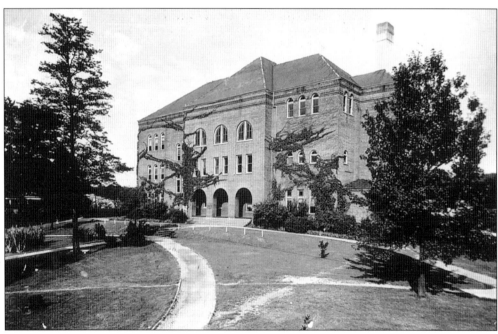

OLD MAIN, 1925. The appearance of the Old Main Building, landmark of the East Lake campus, varied somewhat over its almost 70 years of service. Its original tower was gone by the time of this image. The building was whitewashed as part of Howard's centennial celebrations.

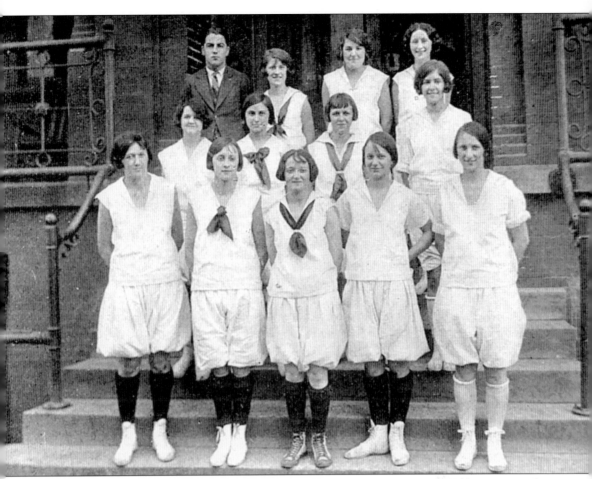

"Bulldog Lassies," 1924–1925. The original caption for this photo credits the "temporal brilliancy" of the Howard College women's basketball team for three victories out of nine games in the 1924–1925 season. Players are identified by last names only, including (front row) Hughes, McNeil, Little, Garret, and Martin; (middle row) Dyer, Majors, Bentley, and Webb; (back row) Coach Shelton, Manager Sadler, Carnley, and Hilton. Today's female students participate in a variety of varsity sports, including softball, volleyball, soccer, golf, cross country, track and field, cheerleading, basketball, and tennis.

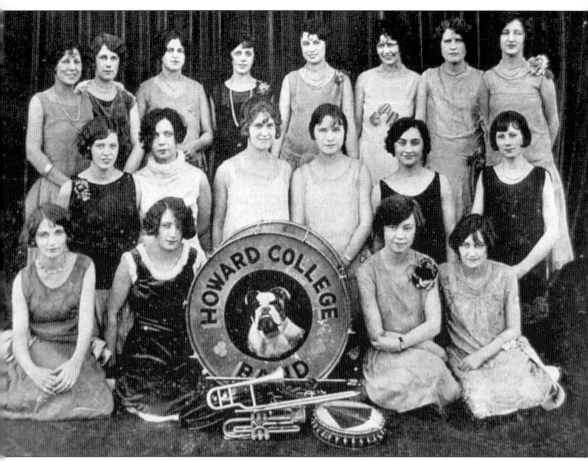

HOWARD COLLEGE GIRLS' GLEE CLUB, 1925–1926. The women are posing with the drum of the college band. Note the image of Howard's bulldog mascot on the drum head. Howard College students chose the mascot by popular vote in 1916. Until then, the athletic teams were known variously as the "Baptist Tigers" or "Baptist Bears."

HOWARD COLLEGE MEN'S GLEE CLUB, 1925–1926. Frank Cokins directed these gentlemen, posing in front of graffiti celebrating the "Rats [freshmen] of 25." Music is as strong a Samford tradition as athletics, for both male and female students. Each generation creates new opportunities for choral and instrumental expression, from gospel to rock, classical to country.

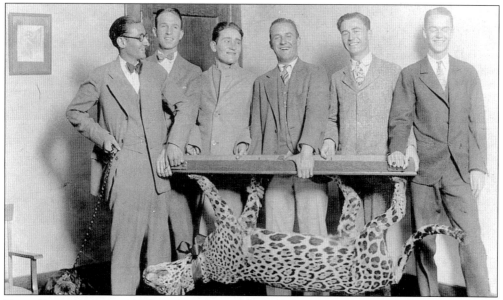

HOLD THAT PANTHER, 1926. Before the 1926 football game between the Howard College Bulldogs and the Birmingham-Southern College Panthers, Howard students snatched their cross-town rivals' stuffed mascot. As more Howard students joined in the mischief they reportedly sang, "Bring back, bring back, bring back my panther to me, to me." The trophy was returned unharmed within a few days, but not before the humiliating photo opportunity recorded here.

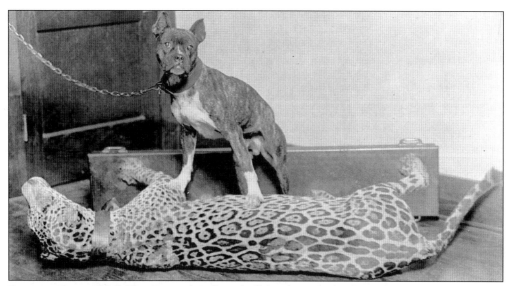

DOGS VS. CATS, 1926. The Howard College bulldog has a go at the stolen Southern panther. Howard College pranksters later sent their rivals a live "panther" mascot, allegedly ordered from Africa. According to contemporary accounts, Birmingham-Southern College officials cautiously opened the panther-size crate to discover a tiny black kitten (*felis domesticus*).

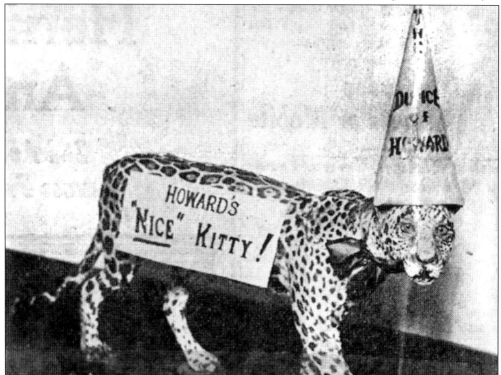

THE LAST STRAW, 1926. Not content merely to upend Birmingham-Southern's stuffed mascot, Howard College pranksters labeled the beast "Howard's 'Nice' Kitty" and added a custom-fit dunce cap. The colleges ratified a peace pact before game day to discourage more serious conflict. Appropriately, the football game ended in a tie.

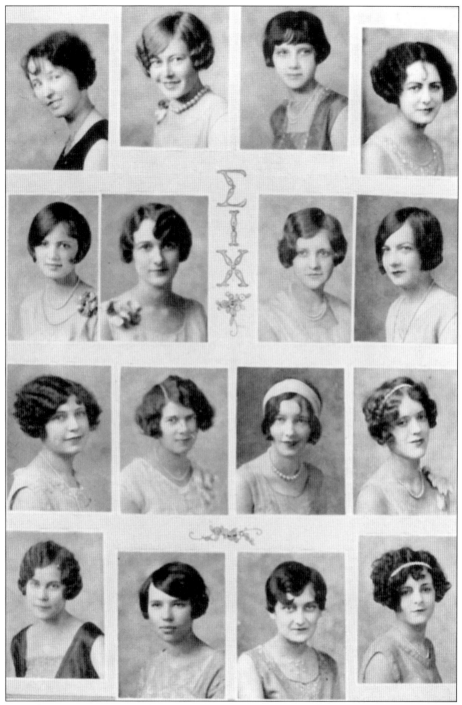

BOBBED HAIR AND ALL, 1926–1927. The sisters of Sigma Iota Chi sorority demonstrate that flapper style caught on at Howard College. Actual flapping was limited by a 1921 ban on dancing. "As to drinking bootleg liquor," Pres. John C. Dawson warned students in 1927, "you are taking your life in your hands as well as violating the law." Pres. Thomas E. Corts officially lifted the dancing ban in 1988 but Samford remains a dry campus.

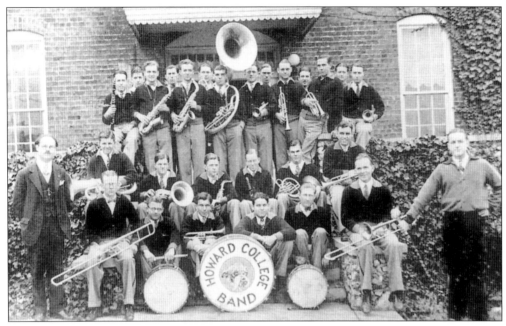

HOWARD COLLEGE BAND, 1926–1927. Fred G. Wiegand directed this band, "one of the young organizations at Howard." According to the impartial editors of the *Entre Nous*, "no college in this section can boast of a better looking, better sounding or better trained band. Well, to make a long story short, that band just struts its stuff and in the field of college bands has no peer."

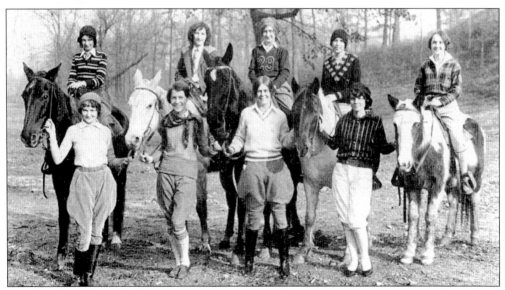

HOWARD COLLEGE GIRLS' SWIMMING AND RIDING CLUB, *c.* 1928. The unidentified women here were among 45 Howard coeds who claimed membership in this unique organization. That's approximately one-sixth of the entire female enrollment of the time (285).

RENFROE HALL, 1929. Like many facilities on Howard's East Lake campus, Renfroe Hall was a multipurpose building. In addition to being the college's dining hall, Renfroe at various times housed civilian male students, Civilian Pilot Training cadets, Navy V-12 trainees, and female students.

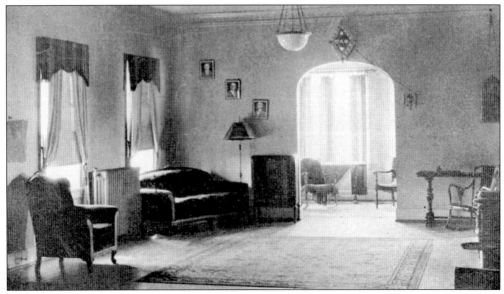

FRATERNITY LIVING ROOM, c. 1930. A small electric sign over the archway at center right identifies this as a room of the Pi Kappa Phi fraternity. During World War II the fraternity house was playfully renamed "Duration Hall." After the war the building absorbed some of the enrollment boom. Resident J. David Griffin recalled that in 1947 the third floor was "one big room containing eight army cots and eight small chests of drawers." Third-floor underclassmen shared a bathroom with older second-floor students, who enjoyed more private quarters.

SHERMAN OAK, 1930. The famous oak on the East Lake campus of Howard College was an unofficial symbol of the college, an oasis on the hot summer days before air conditioning, and a traditional spot for romantic trysts and marriage proposals. Sherman Oak no longer stands but lives on in memory and in the seedlings grown from its acorns and distributed to alumni at homecoming in 1996.

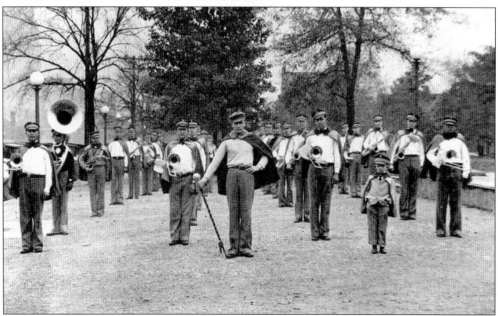

HOWARD COLLEGE MARCHING BAND, 1929–1930. Drum Major Roy Lee, at center, leads the band. The unidentified child at right may be the band's mascot. Surprisingly, children occasionally appear in photographs of this period as class or club mascots. They may be the children of college faculty, administrators, or older students.

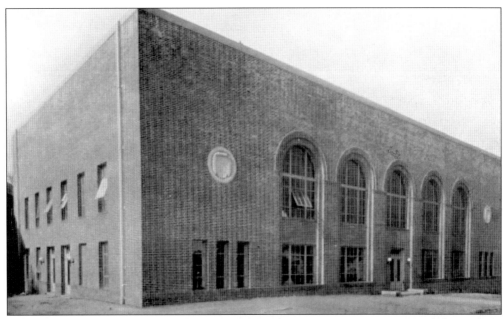

CAUSEY GYMNASIUM, c. 1930. Howard's newly completed athletic facility, named for college registrar O.S. Causey, offered basketball courts, lockers, showers, reception rooms, and, oddly, editorial offices.

HOWARD COLLEGE
TEXT BOOKS AND
COOK BOOKS

PENNANTS, BANNERS
STATIONERY
NOVELTIES

DUCK INN

THE STUDENTS' HANG-OUT
Where College Tastes Predominate

GOOD CHECKS CASHED CHEERFULLY

*"When Hungry or Thirsty Just
Visit Us"*

EXAMINATION BLANKS
ADVICE TO FRESHMEN

EVERYTHING THAT
COLLEGE STUDENTS NEED

BILL BAINS, *Proprietor*

"**GOOD CHECKS CASHED CHEERFULLY,**" **1930s.** Duck Inn (get it?) was a popular Howard College bookstore and soda fountain located in the rear of Old Main. According to a 1930 description of the place, "while some students are listening to the radio broadcast latest musical hits, other students are aiming their cues on the miniature pool tables." One senior student of the time recalled that "we came to know of brief trips to Duck Inn for hamburgers and 'dopes' between classes and at other times when we might have been other places with better profit." The Duck Inn was closed in 1934 when the new college "Co-Op" opened.

47

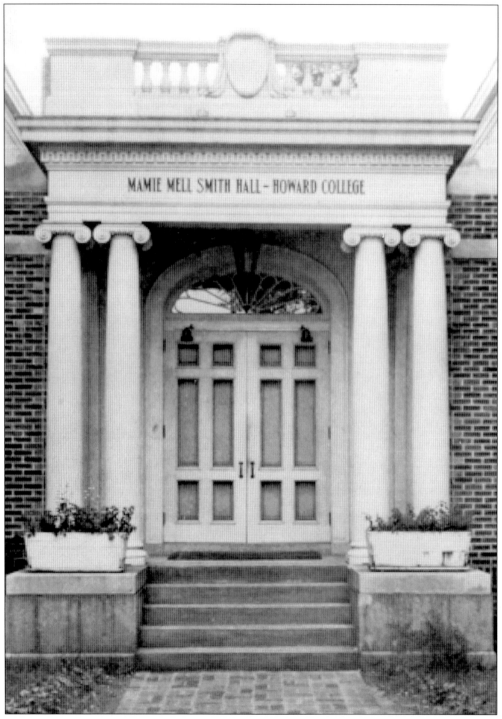

Mamie Mel Smith Hall, 1930. The newly completed East Lake campus dormitory housed 60 female students. A Smith Hall resident of the early 1940s recalled suntanning on the roof and sleeping outside when the moon was pretty. "Usually we waked about 4:00 with rain in our faces and stumbled back to bed, sore from the rocks on our backs."

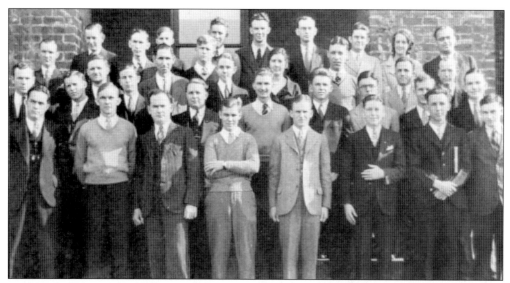

HOWARD COLLEGE MINISTERIAL ASSOCIATION, 1930s. Religious education was among the first concerns of Samford's founders and has been a fixture of the institution throughout its history. Student Christian organizations have encompassed various denominations, foreign and domestic missions, athletics and, of course, preparation for the ministry.

HOWARD COLLEGE SORORITY HOUSES, *c.* 1935. Sorority sisters pose in front of their new, solidly built brick chapter houses. This view is probably of the Phi Mu (left) and Alpha Delta Pi (right) houses. Pres. V.T. Neal promised the women new accommodations as part of his plan for general campus improvements.

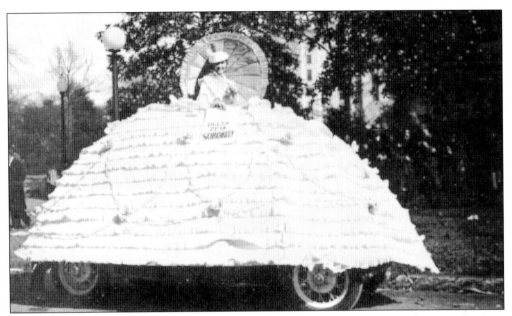

THE BIG PARADE, 1935. Howard's parade events included a float contest. This entry, a giant hoop skirt "worn" by Henrietta Looney, was built by Giles Baker and decorated by the sisters of Delta Zeta. It didn't win!

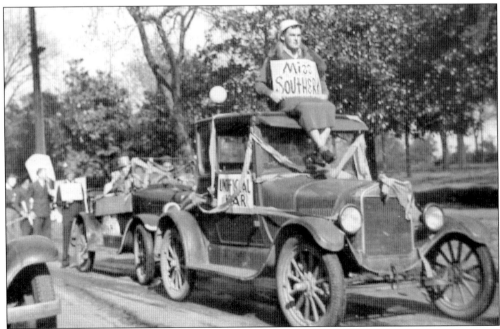

MOCK BIRMINGHAM-SOUTHERN COLLEGE PARADE, 1935. The Howard/Birmingham-Southern rivalry was neither understated nor kind. Here, a Howard man poses as "Miss Southern" atop the "Unofficial Kyar [sic]" of the rival college, followed closely by the "President's Car."

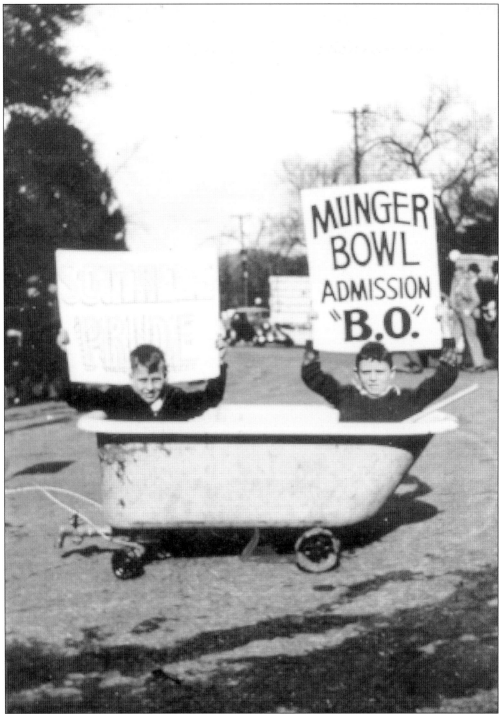

SOUTHERN'S PRIDE, 1935. Two young Bulldog fans apparently posing as Birmingham-Southern College football players, "Southern's Pride," are towed in a wheeled bathtub in the 1935 Howard College parade. The "Munger Bowl" sign refers to Birmingham-Southern's football stadium.

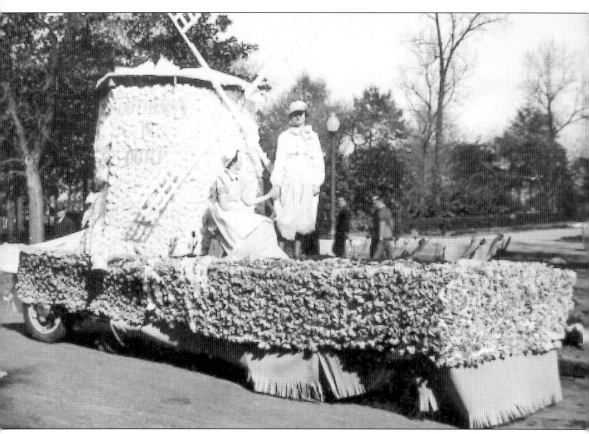

"Southern's In Dutch," 1935. The winner of Howard College's "Caheen Cup," this Phi Mu float depicts a Dutch scene complete with windmill, tulips, and an appropriately costumed couple. Mary Waddey Wilson had charge of this float and may be one the two women shown atop it.

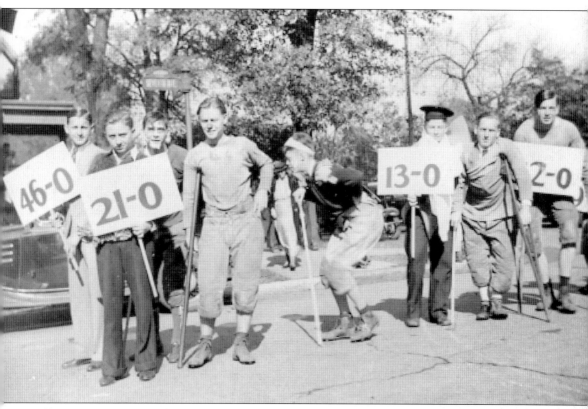

THE VANQUISHED, 1935. Howard College students pose on Seventh Avenue as the various victims of the Bulldog football program. Note lopsided scores, crutches, bandages, and other signs of athletic whipping. Considering the relatively primitive safety equipment of the era, the injuries depicted may be more realistic than we can appreciate.

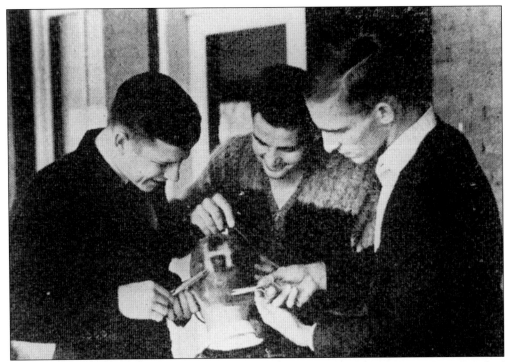

SPIRIT HAIR, 1938–1939. A student identified only as "D.C." helps a group of unidentified freshmen shave the Howard College "H" on the head of a "brother rat."

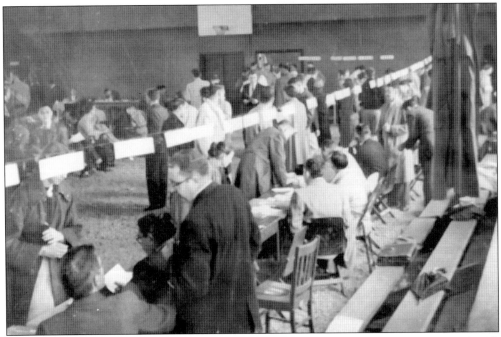

REGISTRATION, *c.* **1930s–1940s.** The floor of Howard's Causey Gymnasium is covered with sawdust to protect it from street shoes as students register for classes. Appropriately, the gymnasium was named for college registrar O.S. Causey.

Four

GIFTS OF WAR AND PEACE

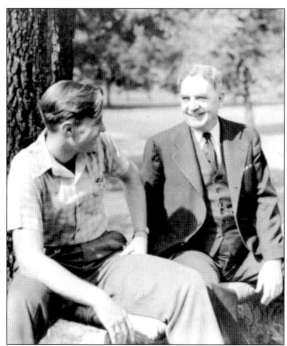

MAJ. HARWELL GOODWIN DAVIS WITH UNIDENTIFIED STUDENT. Davis, the 15th president of Howard College, sought creative ways to save the college as many institutions failed and is credited with securing a Navy V-12 training program during World War II. It seems especially fitting that in 1939 Davis took on leadership of an institution named for a prison reformer. As Alabama attorney general earlier in the century, Davis helped expose the state's unjust convict lease system. Davis led the college through its final relocation, then retired from the presidency in 1958.

OLD YELLERS, 1940–1941. Howard College cheerleaders pile up for the *Entre Nous* on the eve of great wartime change. Pictured are Billy Gwin, L.A. Ratley, Charlie Richey, Jappie Bryant, Charlie Harrison, and Elizabeth Penney.

Howard Mission Group, 1941–1942. Christian missions have long captured the imagination of Samford students. Dr. L.A. Lovegren, a returned missionary from China, was "the chief spark" in the formation of this mission-minded club. The mission tradition continues at Samford University. In the 1999–2000 school year, over 350 students served in short-term missions and local ministries.

1842 1942

HOWARD COLLEGE
OPENS IN JUNE

War is setting the pace with which **Howard enters its second century.** The college will not lower any standard, will not shorten any course, will not cheapen any credit. Yet in this time of national emergency Howard offers its students and incoming Freshmen a **Program so accelerated** that any average student can complete the full course in three years and a superior student can complete the course in two years and one semester.

It is patriotic to get as much education as you can before induction into the nation's services. Speed up by saving the waste of long vacations. Come to Summer School. Lengthen your stride and cross the finish line earlier.

For details consult the Dean or the Registrar.

HOWARD COLLEGE

Harwell G. Davis, President

Birmingham, Alabama

WAR, 1942. This ominous notice announces the creation of Howard College's accelerated wartime degree programs, asserting that "it is patriotic to get as much education as you can before induction into the nation's services." Ambitious students might graduate after only two-and-a-half years of study. Most were expected to graduate in three years. The notice pledges that the new program "will not lower any standard, will not shorten any course, will not cheapen any credit." Program acceleration continued after the war to allow returning veterans to make up lost time.

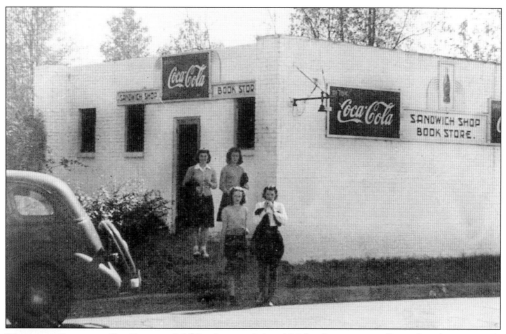

HOWARD COLLEGE CO-OP, *c.* 1942. Opened in 1934, the new college bookstore/soda fountain quickly replaced the Duck Inn as the student hang-out of choice.

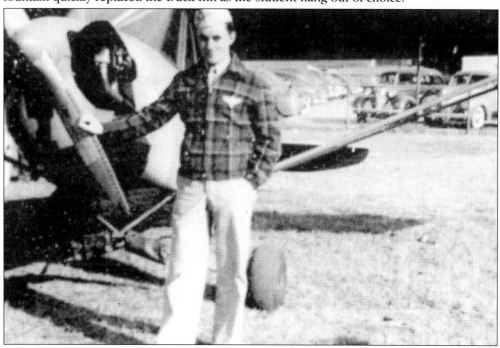

"BAPTIST BOMBER," *c.* 1942. An unidentified Howard student earns his wings in Howard College's Civilian Pilot Training (CPT) Program. The plane shown here may the famous "Baptist Bomber," a Piper Cub used to train the young pilots. The college relocated residents of Renfroe Hall to accommodate the CPT cadets, a measure repeated when the Navy arrived on campus.

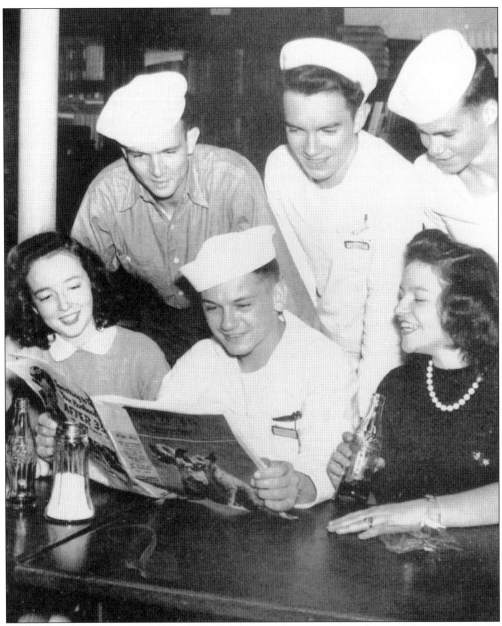

BREAK TIME ABOARD THE "USS *HOWARD*," 1943. Unidentified Navy V-12 trainees and Howard College women share news over the ever-present bottled Coca-Colas, probably in the Co-Op. As other colleges failed due to the economic depression of the 1930s and wartime loss of male students, Pres. Harwell Goodwin Davis sought the U.S. Navy's help in keeping Howard College afloat. The Navy's designation of the college as one site for its V-12 training program brought students as well as funds later used to build the college's new campus.

SOCK IT TO 'EM, BULLDOGS!
c. **1943.** Howard College's
varsity basketball team
included Abe Epsman, Horace
Peterson, Wheeler Flemming,
Al Denham, and Deric Edgar.
Basketball was Howard's
only intercollegiate sport
during wartime. How about
that hosiery?

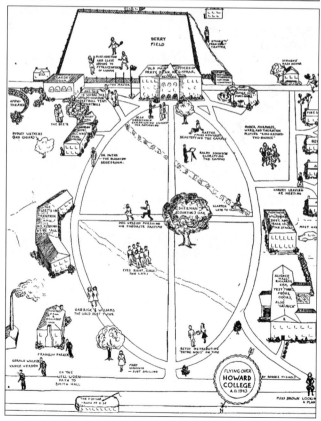

**"FLYING OVER HOWARD
COLLEGE," 1943.** Bobbie
Nichols's wry cartoon map
offers a unique view of
Howard's physical and
cultural campus. "The [V-12]
fleet's in" at Renfroe Hall (left,
middle). "No kidding," added
the artist, "we're all out."
Lingering impressions of the
college's science halls
(bottom, right) included "test
tubes, frogs and odors."

61

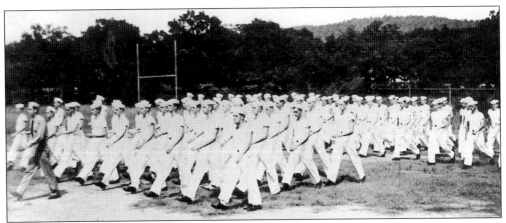

V-12 Students Drill on Howard College's Berry Field, 1943. Over 500 students were enrolled in the V-12 program at Howard College. The nation's combined V-12 programs produced 93 percent of the U.S. Navy's commissioned officers during wartime.

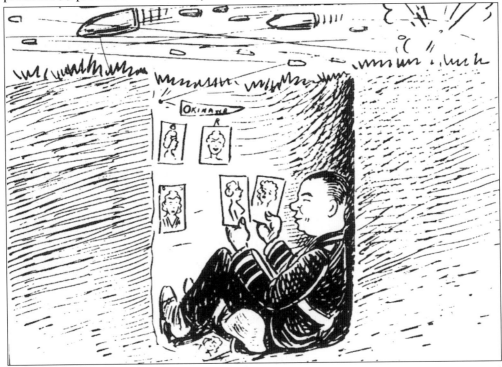

"The Wolf Who Picked 'Em," 1944–1945. Howard students often invited national celebrities to select the annual slate of "Howard College Beauties." Previous judges included legendary director Cecil B. DeMille and vaudeville greats George Burns and Gracie Allen. In the depths of World War II, the patriotic students invited Navy Lt. Comdr. and Howard alumnus Amasa B. Windham to judge the contest even though he was on active duty in the Pacific. This cartoon depicts Windham at the bottom of his foxhole on the island of Okinawa "gazing fondly at the pictures of the beauties, ducking shell bursts, and thinking tenderly of the Madeline [wife] he left in the States." In reality, Windham enlisted the aid of his subordinates to help choose the winners. His radioman proclaimed candidate number four "the loveliest thing he had ever laid eyes on."

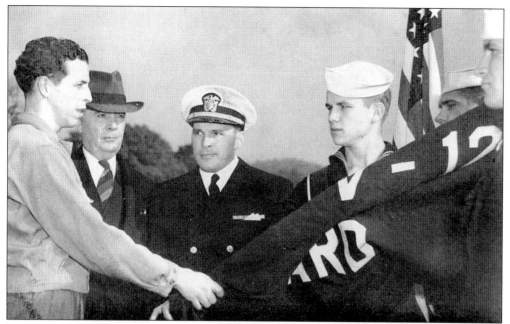

PEACE, 1945. Pres. Harwell Goodwin Davis (second from left) and V-12 program Commanding Officer Lt. Charles A. Schade (third from left) supervise the final lowering of the Navy's flag at Howard College. Schade presented the flag to Howard's archives in the hope that it would "never again be used in wartime." Although the Navy program ended in 1945 its positive effects would prove far-reaching.

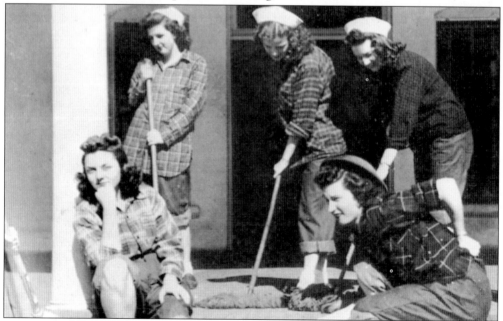

PARADISE REGAINED, 1945. Unidentified students reclaim a dormitory from the Navy. In 1943 Howard College women temporarily surrendered Smith Hall to the sailors of the Navy's V-12 program. "We made fun with it," wrote a displaced Smith Hall resident, "but inside we could not bear to see the boys storming through our sanctuary." Note the sailors' caps.

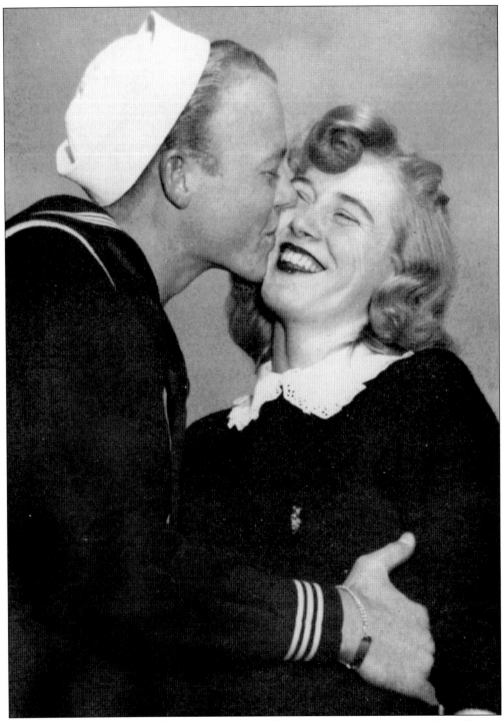

A Bittersweet Farewell, 1945. By war's end the V-12 program had redeemed the military's reputation at Howard College. The inconveniences of the Navy program were compensated for in ways both cultural and financial, and the V-12 sailors seem to have become part of the college family. Here a sailor bids farewell to his Howard "sister."

The Preachers' Intramural Basketball Team, c. 1946. Hugh Chambliss, Billy Gamble, Frank Rains, W.T. "Dub" Edwards, Don Hill, and Calvin Forrester combined Howard's athletic and spiritual traditions. Edwards (front row, far left) later served as chair of Samford's Religion and Philosophy Department.

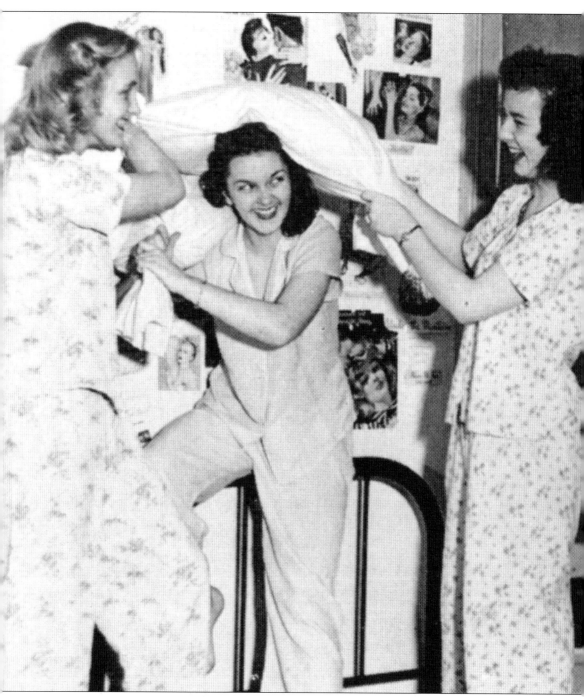

DORMITORY LIFE, 1945–1946. Although apparently posed, this image offers at least a glimpse of life in the women's dormitories of the East Lake campus. The unidentified students are pillowfighting in front of a wall decorated with what appear to be magazine advertisements depicting romantic scenes. According to a wartime resident of Smith Hall, dorm talk was of "dates and furloughs, war widows and weddings, frat pins and engagement rings."

66

FIRE ESCAPE, 1945–1946.
Unidentified Howard College
students demonstrate the
unofficial post-curfew dormitory
exit. When Renfroe Hall became
a residence hall for women,
escape was complicated by
popular housemother J.D.
"Hammie" Hamrick. Hamrick
blinked house lights five times to
warn students, then locked the
women in for the night.

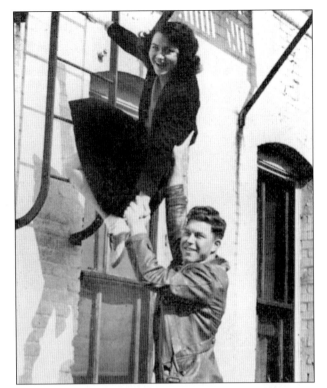

"V," 1945–1946. When the Veteran's Intramural Basketball Team first took to the floor, Howard College students doubted the vets would finish the season. Not only did the team finish, they won the college's intramural championship and fielded the tournament's leading scorer (Denny). Identified by last name only are (front row) Brown, Davis, Gibson, and Hall; (back row) Sloan, Keller, and Denny.

HOME, 1945–1946. Seen here are some of the returning veterans who swelled Howard College enrollments thanks in part to the GI Bill. George Giddens, Othimil Whitman, and Robert Knight are pictured with two unidentified veterans. Proceeds from GI Bill tuition and the V-12 program helped Howard make needed improvements and additions even as its leaders searched for a new campus.

A NEW KIND OF DORMITORY LIFE, 1947–1948. Howard College made special housing arrangements to accommodate veterans returning to school with new families. Here the unidentified wives and children of Howard students enjoy a game of cards around a table in the married veterans' apartments.

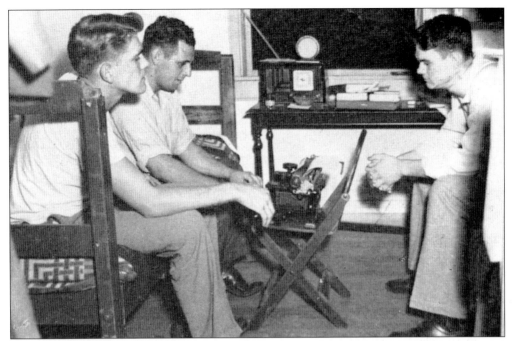

VETERANS' BARRACKS, 1947–1948. Although not as well-appointed as married veterans' apartments, Howard's barracks rooms for single veterans were comfortable and inexpensive. With only two students per room, the barracks were not as crowded as during wartime. The unidentified students pictured here are using a folding chair as a typewriter stand.

HOWARD COLLEGE EXTENSION CLASS, LATE 1940s. Gilbert L. Guffin, pictured in the foreground at far left, led the college's Extension Department for Christian Training. The department allowed ministers and church workers to pursue college education relevant to their calling without traveling to Birmingham. By 1948 the popular program had 28 extension units in place throughout the state.

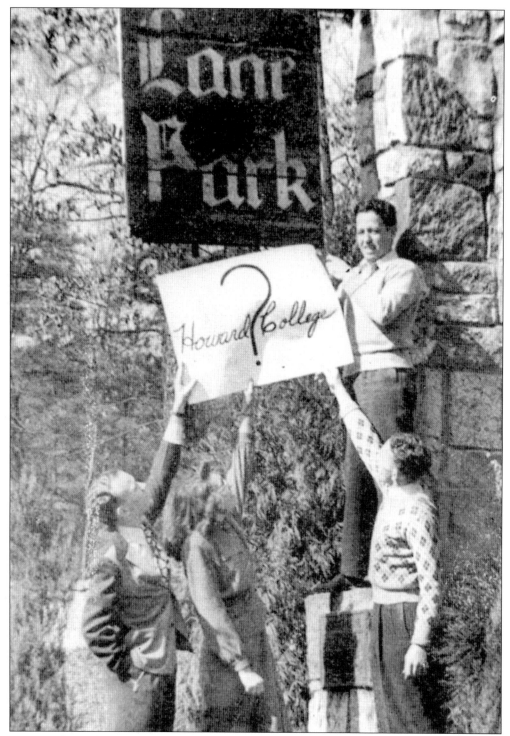

LOST, 1946–1947. With a surplus of funds from the war years and postwar enrollment boom, President Davis and Howard trustees searched for a new home for the college. Here students audition Lane Park for the role.

70

FOUND, LATE 1940S–EARLY 1950S. Unidentified Howard students pose on the Shades Valley hillside that would soon be the college's final home. Construction for the new campus began in 1953.

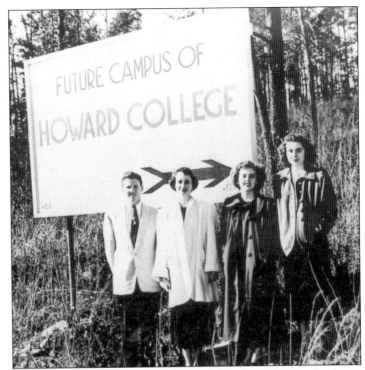

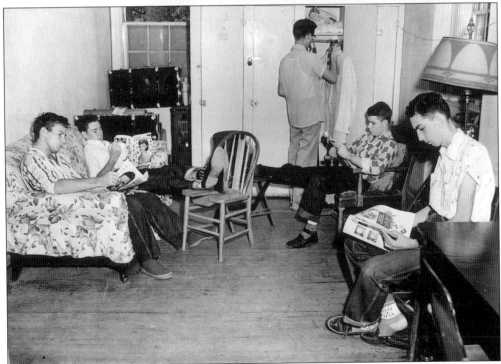

DORMITORY LIFE, 1940S OR 1950S. Unidentified students relax in an East Lake dorm room. The worn, bare wooden floor and mismatched furniture are indicative of the problems of the aging campus.

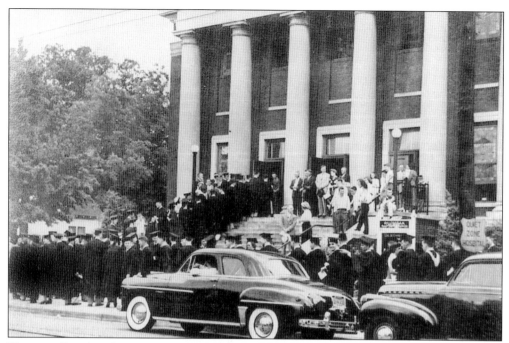

HOWARD COLLEGE COMMENCEMENT AT RUHAMA BAPTIST CHURCH, c. 1951. Ruhama Baptist Church served for decades as Howard College's spiritual home. Its location near the East Lake campus made it especially convenient for graduation exercises.

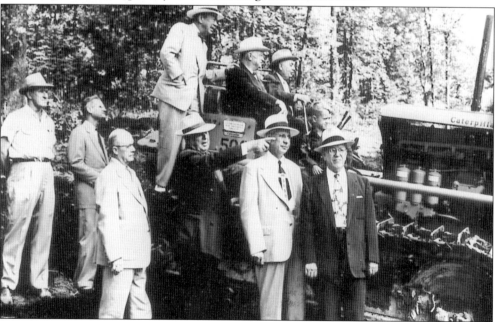

GROUNDBREAKING FOR A NEW CAMPUS, 1953. Seen from left to right are (on ground) D.W. Ellard, contractor; Charles B. Davis, architect; E.B. Van Keuren, architect; John H. Buchanan; John G. Burton, college business manager; and Percy Pratt Burns, college dean; (on tractor) Frank Park Samford Sr., board of trustees president; Paul A. Redmond, trustee; Harwell Davis, president of the college; and Davis's grandson, Bill Eshelman.

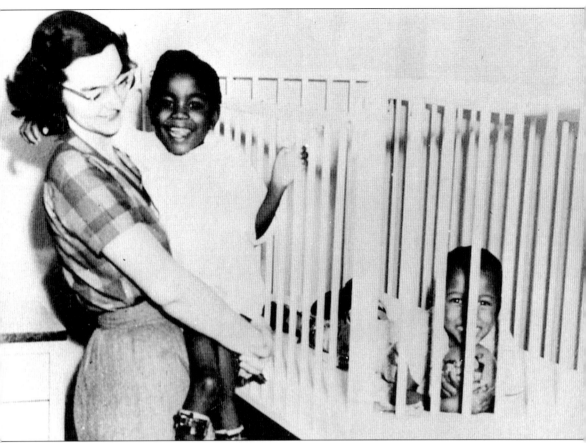

HOWARD COLLEGE MINISTRY, 1950s. An unidentified member of the Howard College Mission Band holds a child at the Birmingham Crippled Children's Clinic. The student volunteers worked in children's homes and hospitals, juvenile courts, and nursing homes. The tradition of Christian community service continues. In the 1999–2000 school year, over 200 Samford students served in local ministries such as Habitat for Humanity and in projects serving disadvantaged children and senior citizens.

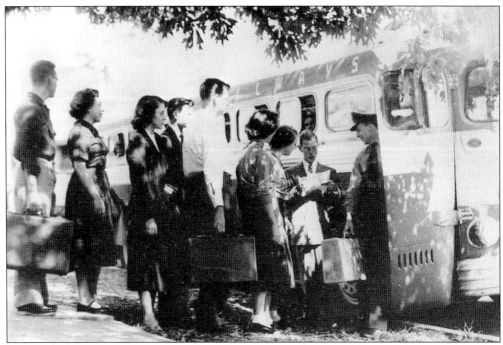

HOWARD COLLEGE STUDENTS BOUND FOR BAPTIST STUDENT CONVENTION, 1952–1953. The students pictured here are members of the Baptist Student Union (BSU), one of the many Christian student organizations on campus. The BSU sponsored revivals and other special religious programs and, as here, offered Baptist students the chance to influence the course of their denomination.

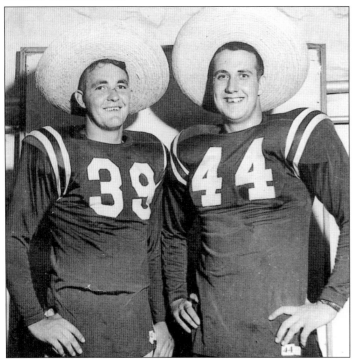

PERROS CONTRA GATOS, 1955. Howard football team captain James Chandler (#39) and alternate captain Wayne Walker (#44) pose in sombreros at their homecoming game against the University of Mexico Pumas. The game was good natured in spite of the 41-13 drubbing of the Bulldogs. This event was the first time a Mexican team had played in Alabama and the first time flags of two different countries had flown over Birmingham's legendary Legion Field.

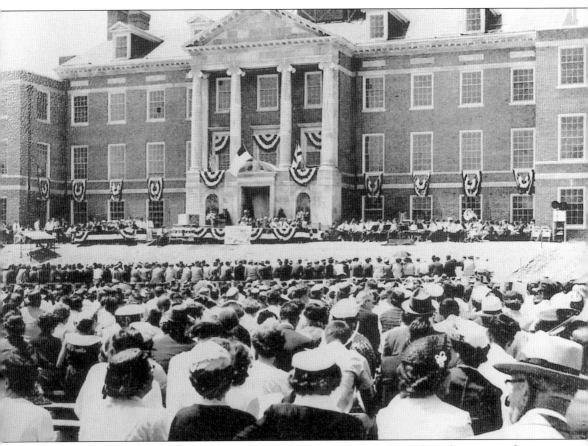

DEDICATION OF SAMFORD HALL, 1955. President Davis clung tenaciously to his vision of an architecturally uniform Georgian-Colonial campus for Howard College, and the integrity of that vision is maintained in every new building project. "Of all earthly treasures," said Pres. Thomas E. Corts, "the Samford campus is Major Davis' monument." Pictured here is the dedication of the almost-complete Samford Hall, the administration building of Howard's new campus. The college did not occupy its new facilities until 1957.

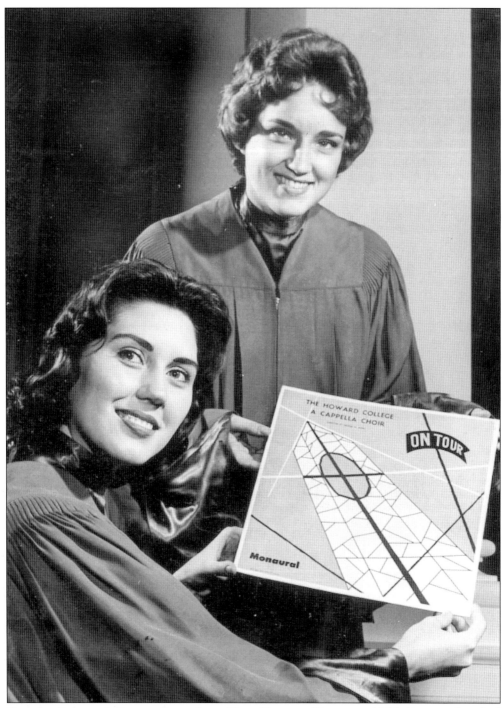

HOWARD COLLEGE A CAPELLA CHOIR SINGS YOUR FAVORITE HYMNS, *c.* 1956. Two unidentified members display the a capella choir's album of 25 songs. George W. Koski, church music authority and director of Howard's Music Department, reorganized and expanded the a capella choir in 1949. An original of the album shown here remains in the Special Collection Department of Samford University Library.

XAN HALL, 1950s. The limited growth potential of Howard's East Lake campus is well illustrated by this image of a women's residence there. Dorothy Smith Flynt, among the last residents of Xan Hall, recalled that moving into Vail dormitory on Howard's new campus "was like moving into a palace."

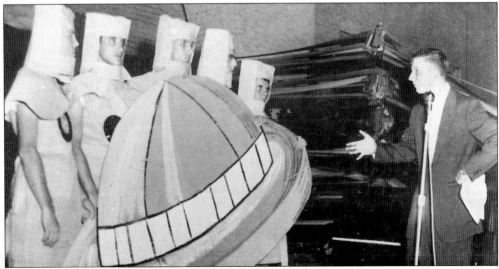

HOMECOMING SKIT, 1956. Master of Ceremonies Bob Curlee welcomes the Flying Saucer Men to Homecoming festivities. Asked if Flying Saucer Men are "for real," head Saucer Man Lindsey O'Rear replied, "Yes, it's me and I'm In Love Again"—a reference to the Fats Domino hit of 1956.

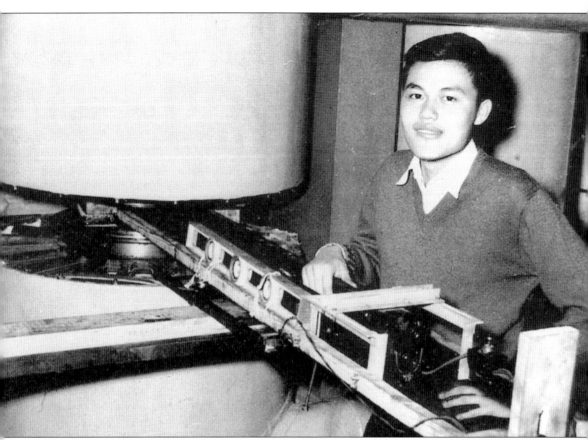

"Howard's Pride and Joy," 1957. Student Shui Fong Yeung poses with the South's first cyclotron, still under construction at the time of this photograph. Howard chemistry majors Robert Smith, James Tarrant, and Megill Echols began building the atom-smasher in 1948. Construction and refinement of the device continued for many years, and it eventually found a home on the west side of the college's new campus.

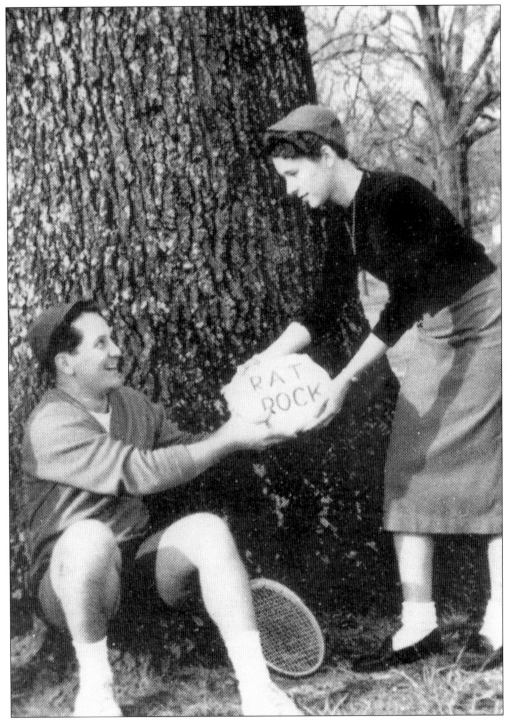

RATS, *c.* 1956. During Rat Week, Judy Ferris and Head Rat Max Gartman wear Rat Hats and display the notorious Rat Rock. Rat Week rules gave upperclassmen the right of inspection-on-demand of freshmen at the rock. Gartman later joined Howard College's faculty and became head of Samford's Department of Foreign Languages.

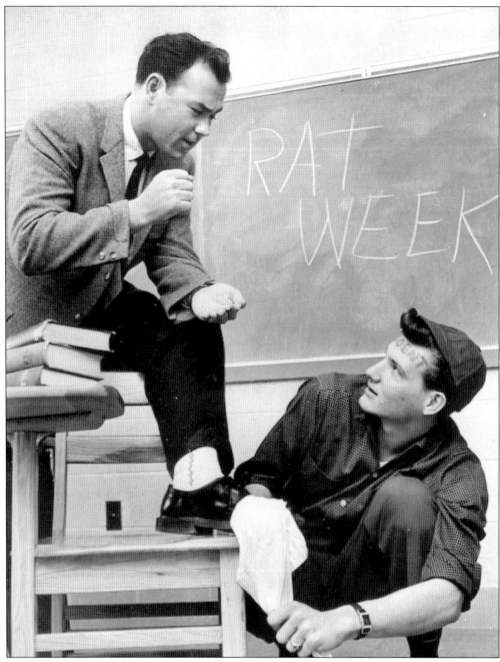

SHINE, RODENT, SHINE, *c*. 1956. Howard College upperclassman George Smith exercises his Rat Week authority over an unidentified freshmen by demanding a shoeshine. In addition to prohibiting makeup and shaving, Rat Week rules required freshmen to wear mismatched shoes (a contemporary account makes special mention of Rita Booker's pairing of a combat boot and loafer). Smith later served as Samford University's director of Public Relations.

Five

A NEW HOME,
A NEW NAME

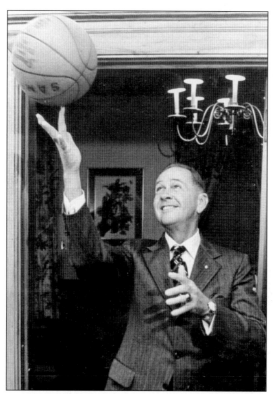

LESLIE S. WRIGHT. Samford University president Leslie S. Wright recalls his days as captain of the University of Louisville's basketball team. Wright served as Samford's president from 1958 to 1983, the longest tenure to date, then served as university chancellor for the remainder of his life.

Mud! *c.* **1957.** Unlike today's lush, landscaped campus, mud was the outstanding environmental feature of Howard's new campus in the late 1950s. What seemed to be an especially wet season left sidewalks covered with the stuff. Note the empty bell tower of the library. Samford's famous carillon was not moved to the library from the Reid Chapel tower until 1979.

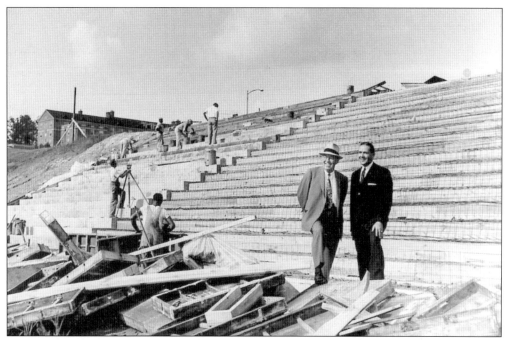

A NEW STADIUM, *c*. 1958. Trustee Frank Park Samford and Pres. Leslie S. Wright pose amidst construction of Howard College's new stadium. The facility hosted its first football game in 1958, but was not completed until 1961, when it was named in honor of benefactor F. Page Seibert. Extensively renovated in the 1980s and 1990s, the 6,700-seat stadium now includes the four-level, Georgian-Colonial Bashinsky Press Tower and is the nation's finest I-AA football facility.

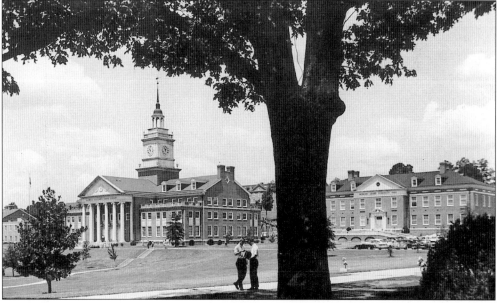

GRASS! LATE 1950s. By the time of this photograph, grass had replaced the notorious mud of Howard College's quadrangle. This view from James H. Chapman Hall encompasses Harwell Goodwin Davis Library (left) and Memory L. Robinson Hall (right).

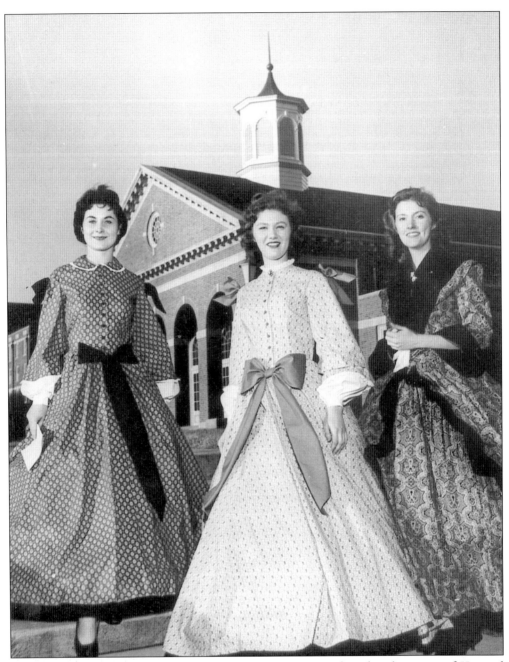

WILLIAMSBURG IN ALABAMA, 1959. The stunning Georgian-Colonial architecture of Howard College's new campus inspired favorable comparisons to the recreated community of Colonial Williamsburg, Virginia. Pictured from left to right, Carolyn Whitehead, Pat Howard, and Lana Joan Andrews dress the part.

STEP SING WINNERS, 1950S OR 1960S. The unidentified winners pose with one of several annual prizes. Step Sing originated in the early 1950s as a small-scale performance on the steps of Old Main on the East Lake campus of Howard College. The event later moved indoors and onto risers. Modern Step Sings feature elaborately choreographed and costumed musical medleys performed by groups of students on the stage of Samford's Leslie Stephen Wright Fine Arts Center.

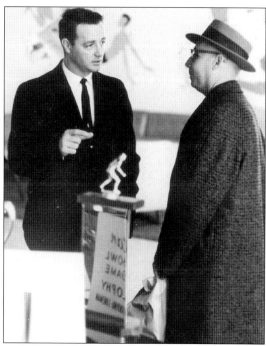

BOBBY BOWDEN, *c*. 1960. Howard College football coach Bobby Bowden speaks with sports writer Ronald Weathers near some of the college's athletic trophies. The legendary coach was a Little All-American quarterback at Howard in the 1950s, then returned to coach the team from 1959 to 1962. Three of Bowden's sons later served Samford University.

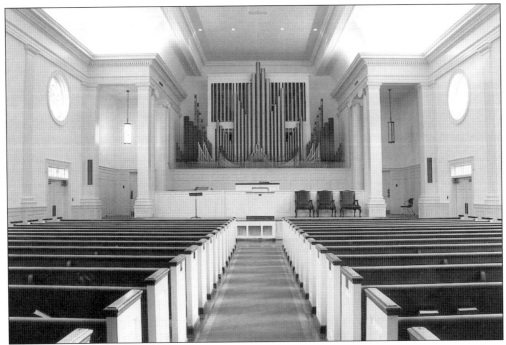

A. HAMILTON REID CHAPEL. An interior view shows Samford's first chapel, completed in 1960. The chapel is one of the university's signature buildings, the site of many a convocation, and favored venue for alumni weddings.

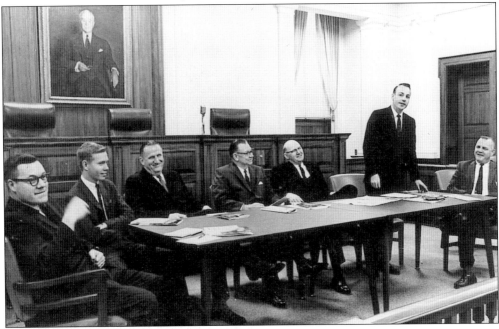

GOV. ALBERT P. BREWER AT CUMBERLAND LAW SCHOOL, 1960s. Brewer, governor of Alabama from 1968 to 1971, joined the faculty of Samford's Cumberland School of Law in 1987. He is pictured here not long after the renowned school was acquired by Howard College in 1961. Cumberland is one of only two accredited schools of law in Alabama.

J.D. PITTMAN MEN'S RESIDENCE, 1960s. The dorm is little changed today and still serves as one of the underclassmen residence halls of Samford's central campus. Pittman Hall now also houses the university's Wellness Center.

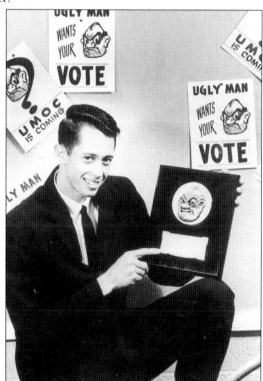

UGLY MAN CONTEST, 1962. Ricky White, chairman of Howard's annual Ugly Man Contest, shows off the Ugly Man prize. Entrants typically made horrible faces for the camera, then posted their photos over jars. Students selected a winner by dropping pennies in the jars. Proceeds of the contest went to charities such as the March of Dimes.

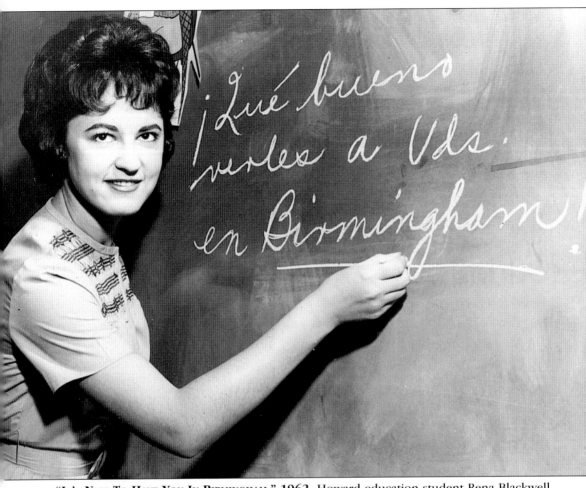

"It's Nice To Have You In Birmingham," 1962. Howard education student Rena Blackwell welcomed the University of Mexico football team back to town after seven years without a game between the schools. Mexico's Pumas soundly beat Howard in the 1950s but Bobby Bowden's Bulldogs skunked them 40-0 in the 1962 match.

PUSH-UPS, 1962. Pictured from left to right, John Carter, Ruric Wheeler, and Lindy Martin hit the deck under the command of Nathan Stott. The faculty group was in training for the upcoming faculty-student basketball game. They beat the students 48-46. The workout pictured here no doubt gave them the two-point advantage.

"WESTWARD HO," 1962. The pioneer theme of the college's annual H Day celebration encouraged Howard men to start growing '49er-style beards months before the early May event. In March, Rod Conrad (left) and James Tidwell (right) tried out their new beards on Lucy Barrow.

INTRAMURAL FOOTBALL, 1960s. An unidentified Cumberland School of Law student breaks away from Pi Kappa Alpha players. Samford's commitment to "nurturing persons" encompasses physical as well as intellectual and spiritual development. In addition to intramural sports and undergraduate physical education requirements, Samford offers 11 varsity sports, including softball, baseball, volleyball, soccer, golf, cross country, track and field, cheerleading, football, basketball, and tennis.

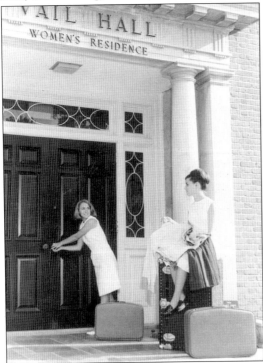

MOVING DAY, 1960s. Unidentified residents of Lena Vail Davis Hall prepare to move into their dormitory rooms. Vail Hall was the only women's dorm completed at the time Howard College relocated to its new campus in Shades Valley.

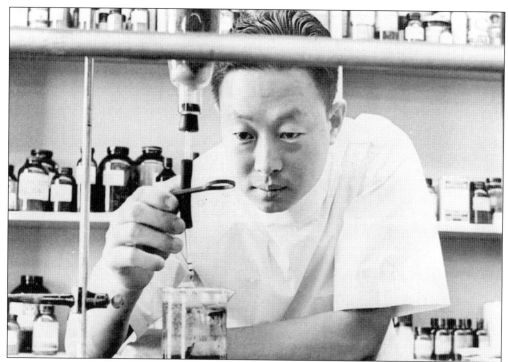

TEA SAM ROE, 1960S. Professor Roe, who has now served Samford University for over three decades, is shown at work in Howard College's pharmacy program, established in 1927. In 1996 the program was named the McWhorter School of Pharmacy in honor of Samford alumnus and school of pharmacy benefactor Clayton McWhorter.

FROM HOWARD COLLEGE TO SAMFORD UNIVERSITY, 1965. Seen here from left to right, Buddy Huey, Bill Pendergrass, Doug Garner, and Murray Howard make the change. Earning university status presented a problem because the name "Howard University" was already taken. The institution was renamed Samford University in honor of longtime trustee Frank Park Samford Sr. The Howard College of Arts and Sciences still forms the academic core of the university.

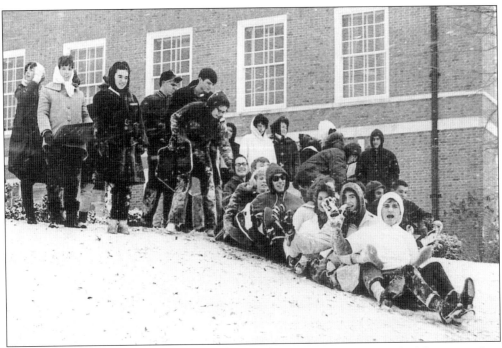

A Winter Tray-dition, 1966. On the rare occasions that North Central Alabama receives more snow than ice, Samford students turn the hilly campus into a winter amusement park, traditionally atop trays borrowed from the cafeteria. Eddie Austin leads this "tray-train" during the big snow of 1966.

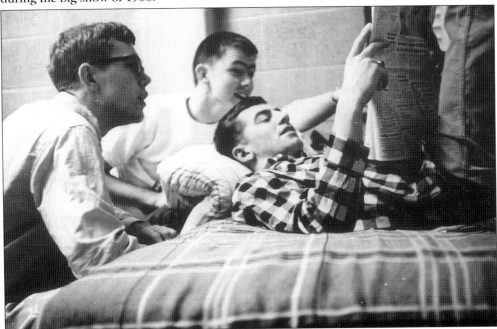

Dormitory Life, 1966. John Lee, Dave Mullins, and Bobby Camp share an issue of the *Crimson*. Founded in 1915, the *Crimson* is the most complete record of daily campus life. It survived censorship controversies of the 1970s and continues publication.

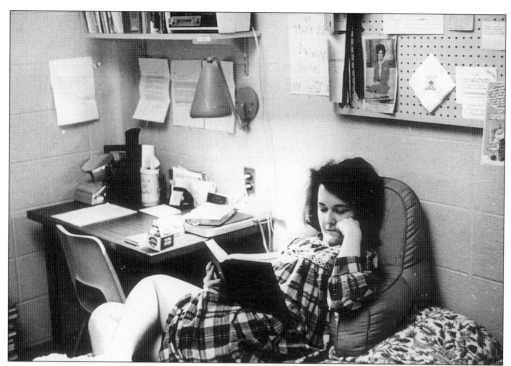

DORMITORY LIFE, 1966. Samford student Ruth Wells studies in her room in this rare, candid view of women's dorm life.

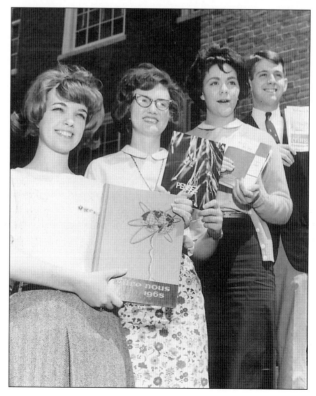

PUBLICATIONS EDITORS, 1966. Carolyn Strom, Martha Myers, Dian Whitehead, and Andy Collins hold the four traditional Howard College publications: *Entre Nous*, the college annual; *Pensez*, the student literary magazine; *Bullpup*, the guide to student life; and the *Crimson*, the student newspaper.

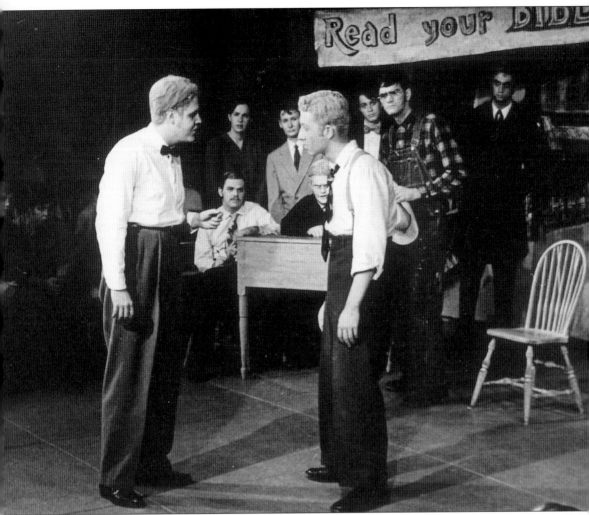

INHERIT THE WIND, 1969. Student theater is a popular and longstanding tradition at Samford. Professor and play director Harold Hunt noted that this production, a dramatized account of the infamous "Scopes Monkey Trial" of 1925, had both historical and contemporary significance. The two student actors pictured in the foreground here, Randy Marsh (left) and Jesse Bates (right), played the key roles of attorneys Matthew Harrison Brady and Henry Drummond.

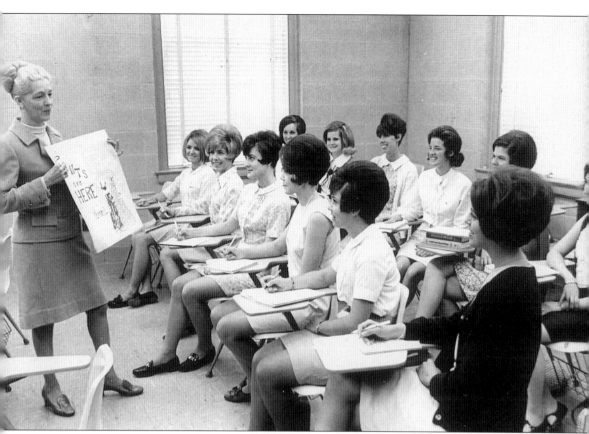

PANTS ARE NOT HERE, LATE 1960s. Notwithstanding the sign held by the professor ("Pants Are Here"), clothing styles suggest that this image dates from Samford's late pre-pants era. In the early 1970s, a group of female students wore trousers and long coats to class one day. When told they could not remain in class dressed as they were, the women complied with university rules by removing their pants. The pants ban was dropped shortly afterward.

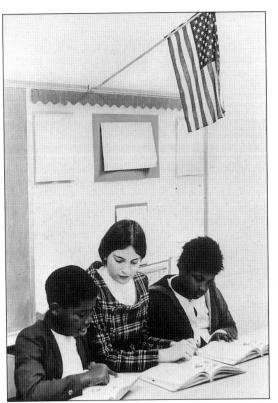

HANDS-ON EDUCATION, 1971. An unidentified Samford education student serves as a reading tutor at Wenonah School. Samford's award-winning Orlean Bullard Beeson School of Education and Professional Studies continues to send its students into schools both public and private, rich and poor, to prepare for the real-world challenges of teaching.

GROUNDBREAKING, 1971. Leaders of Samford University's "Decisive Years" campaign break ground for the $1.6-million Ralph W. Beeson University Center. Pictured from left to right are R.J. Stockham, Ben Brown, Leslie Wright, Frank Park Samford, and Gerow Hodges. The center is only one of many major construction projects at Samford supported by the Beeson family, whose gifts currently total over $100 million.

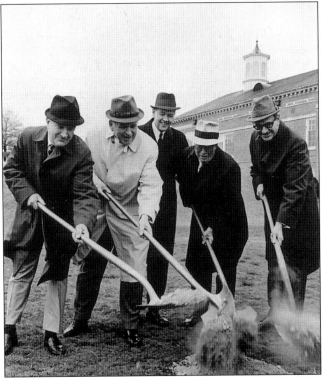

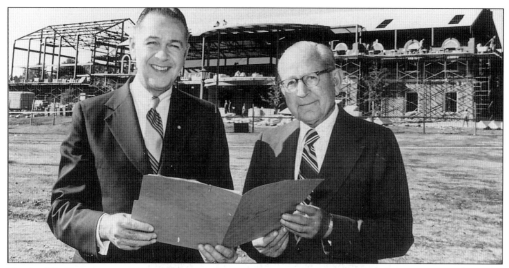

RALPH W. BEESON, *c.* **1972.** Pres. Leslie Wright stands with Ralph W. Beeson in front of construction for the University Center named in Beeson's honor. Other building projects supported by the Beeson family include the Beeson Woods Residence Halls, Orlean Bullard Beeson Hall, Dwight M. Beeson Hall, Dwight and Lucille Beeson Center for the Healing Arts, Beeson Divinity School, and the Lucille Stewart Beeson Law Library.

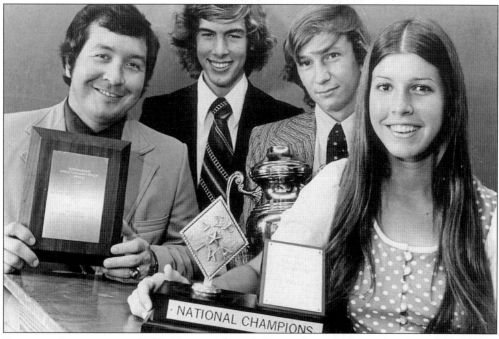

NATIONAL CHAMPIONS, *c.* **1972.** Pictured from left to right, Coach Brad Bishop, Tim Zeiger, John Benn, and Virginia Causey display honors of the debate season. Under Bishop's direction Samford's debaters distinguished themselves with an unprecedented three-win record in the Tau Kappa Alpha–Delta Sigma Rho national four-man debate championships. The team competed against debaters from UCLA, Wake Forest, and Harvard. Samford's reputation in debate began over a decade earlier under the leadership of speech professor Al Yeomans.

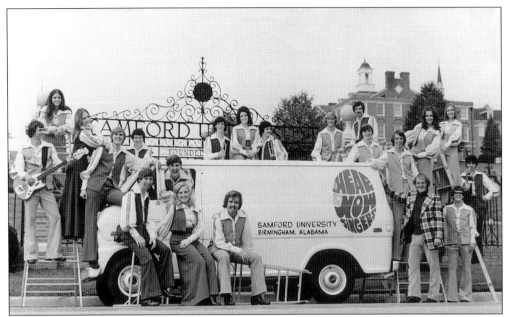

THE HEAR AND NOW SINGERS, 1972. Members of the popular Samford singing group pose beside their van at the university's front gate. Director Bob Burroughs, in plaid jacket, stands at right. The group took its combination of modern music and traditional Christian messages throughout the region, setting out on a ten-day, five-state tour around the time of this photograph.

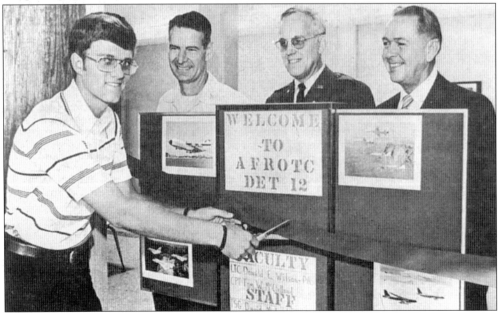

AIR FORCE ROTC, 1972. Samford student and first cadet commandant David Bean officially opens the university's new facility for Air Force ROTC on the south side of Crawford Johnson Hall. Seen here, from left to right, are Bean, area commandant Col. Peter D. Summer, Samford professor of aerospace studies Lt. Col. Donald E. Wilson, and Pres. Leslie S. Wright. The program continues, graduating 10 to 15 cadets each year.

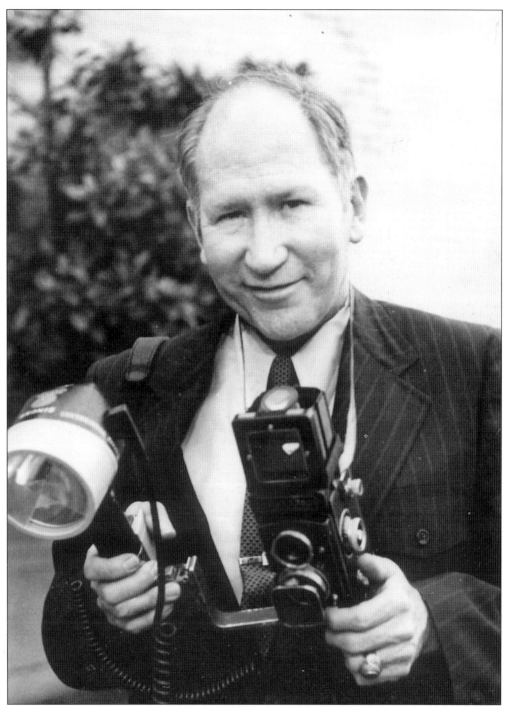

DIRECTOR OF PHOTOGRAPHIC SERVICES LEWIS "LEW" ARNOLD, 1973. A fixture at Samford University for over three decades, Arnold made many of the photographs in this book. His print and negative archive contains thousands of images of every detail of campus life. Arnold also taught in the university's journalism department, passing along his craft to new generations of photojournalists.

ANOTHER VOICE

VOLUME ONE, NUMBER ONE BIRMINGHAM, ALABAMA FRIDAY, FEBRUARY 9, 19

Edgewood lakebed stirs heated controversy

BY BILL STEVERSON
A-V staff writer

Some 85 acres of land south of Lakeshore Drive between Homewood High School and Greensprings Highway is the subject of a heated controversy between Samford University, which owns the land, and a group of Homewood residents, who oppose Samford's attempts to have the land zoned for commercial use.

The controversy is not young; it began several years before Samford moved from it's East Lake campus to Shades Valley in 1957 and

themselves the Coalition of Concerned Citizens to save the Edgewood Lakebed has cited as reasons for their protests Samford's clearing of part of the land, it's announcement of it's intention to develop all the land, and the channelization of Shades Creek in the Brookwood Mall area.

They also are protesting why they say will be an increased flooding problem along Shades and Griffin Creeks and the alleged moral obligation of Samford to let the area remain in it's original state of ecological purposes.

The citizens have cried

most of the land w purchased by Investo Syndicate, Inc.

On Nov. 15, 194 Investors Syndicate gave t quitclaim deed to Edgewo Lake (about 127 acres) Jefferson County. The de set forth strict conditions which the county had abide.

The deed said the la could not be used f anything except a parkw and that the county wou provide for upkeep of t dam.

"It is agreed that sa property shall not be used

ANOTHER VOICE, 1973. Citing a lack of journalistic freedom, *Crimson* editor H. Randall Williams and colleagues resigned from the student newspaper in 1972. In 1973 they launched the controversial independent newspaper *Another Voice* as a professional and objective alternative to the *Crimson*. The *Crimson* continued with a replacement staff and *Another Voice* was later rated a "First Class" college newspaper by the Associated College Press.

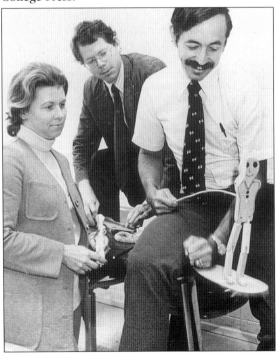

JUST FOLKS, c. 1974. Three of Samford's history faculty demonstrate Southern folkways. From left to right, Leah Atkins holds a cornshuck doll, Jim Brown plays the mountain dulcimer ,and Wayne Flynt demonstrates the limberjack dancing doll.

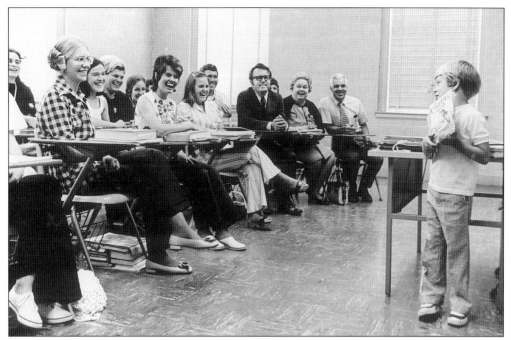

"Pay Attention and Write Down What I'm Telling You," *c.* **1974.** Leland Allen, son of then dean of graduate studies Lee N. Allen and wife Catherine, shares the writings of E.B. White with education students in a children's literature class. He strongly urged the students to take notes.

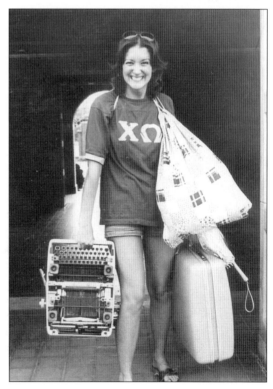

Moving Day, 1975. An unidentified sister of Samford's Chi Omega sorority carries her luggage and typewriter through the courtyard of Crawford Johnson men's dormitory on the way to her own residence hall.

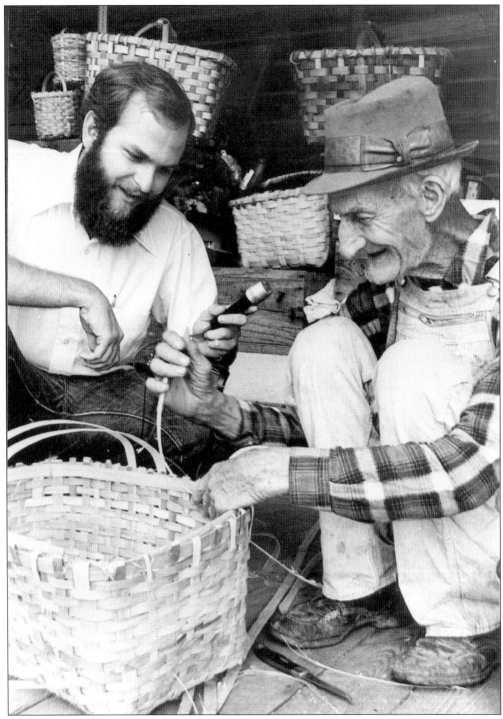

WHITE OAK BASKETRY, *c*. 1976. Samford student Mark Gooch documents the work of master folk-craftsman Homer Rigsby, age 86 at the time of this photograph. A grant from the National Endowment for the Humanities helped Gooch conduct field research into Alabama folk culture.

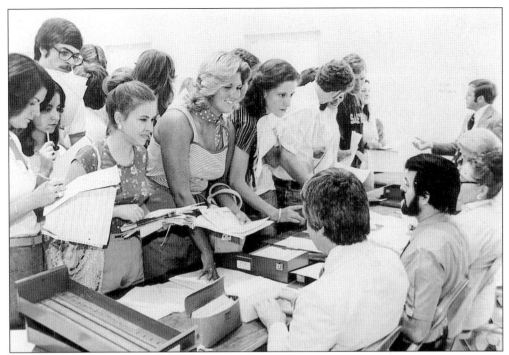

Registration, 1976. Students crowd registration tables to select their courses. Except for the absence of sawdust on the floor, this scene is not far removed from registration procedures of earlier generations.

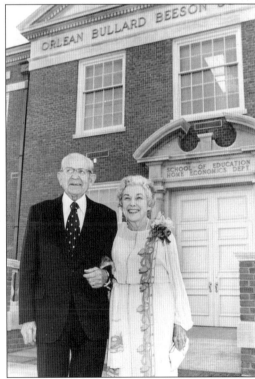

Ralph and Orlean Bullard Beeson, c. 1979. The Samford benefactors stand before one of the many campus buildings to bear their name. The building shown here is home to Samford's Orlean Bullard Beeson School of Education and Professional Studies.

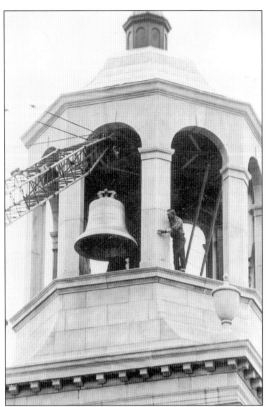

RE-INSTALLING THE BELLS, 1979. The Rushton Memorial Carillon, so familiar to Samford students from the late 1960s through the present, is among the finest in the nation. The 49 bells of the original set, together weighing more than 5 tons and covering 4 octaves, were cast in Asten, Holland, at the renowned Schulmerich-Eljsbouts Bell Foundry. The carillon was first installed in the bell tower of Reid Chapel in 1968. It was expanded and relocated to the library's bell tower in 1979.

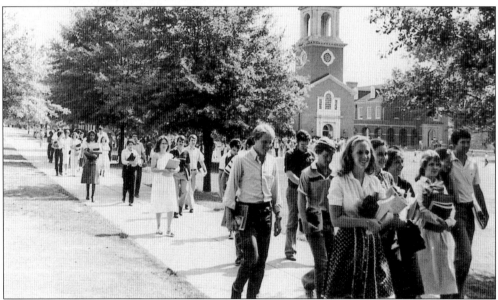

CONVO'S OUT, 1970s OR 1980s. A stream of students emerges from Reid Chapel, the traditional site of Samford's convocation offerings. "Convo" attendance, required for undergraduate degrees, brings students into Samford's community of faith, learning, and values rooted in a Christian world view. The program features a variety of activities, from musical presentations to distinguished guest speakers.

Six

THE BEST IS YET TO BE

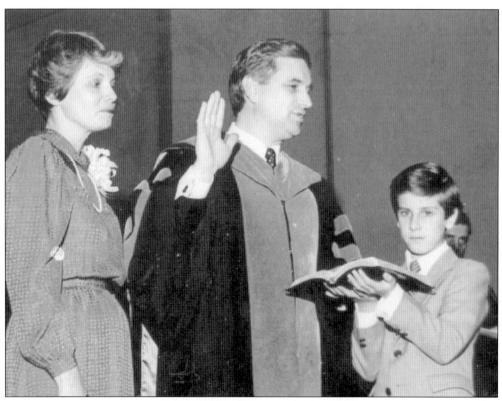

INAUGURATION OF PRES. THOMAS E. CORTS, 1983. Samford's 17th president takes his oath of office beside wife Marla and son Chris. Samford University has grown dramatically under the Corts administration. Highlights of his tenure include record enrollments, expanding international programs, at least a half-dozen major building projects, and an endowment of over $300 million.

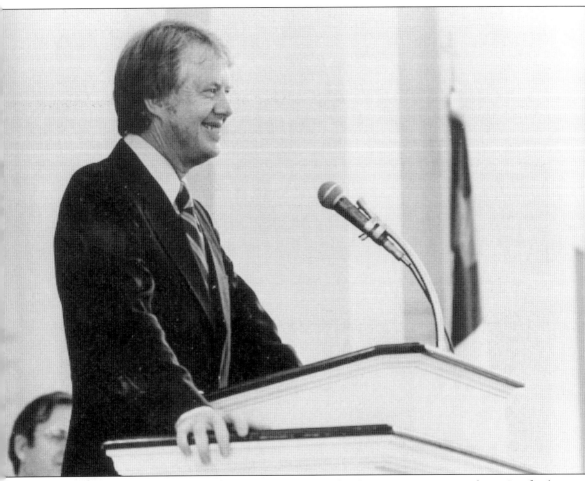

U.S. Pres. Jimmy Carter, 1984. Progressive Baptist leader Jimmy Carter speaks in Samford University's Reid Chapel. Many important (and/or controversial) political figures of the last half of the 20th century have spoken at Samford. Other distinguished guests included Ronald Reagan, George Bush (the elder), Margaret Thatcher, John Major, Condoleeza Rice, John Ashcroft, Janet Reno, Bill Clinton, Richard Nixon, G. Gordon Liddy, Clarence Thomas, Kenneth Starr, Fred Shuttlesworth, Morris Dees, and George Wallace.

SAMFORD UNIVERSITY MASCOT, 1985. Samford student Christy Stephens poses in costume as the university's English bulldog mascot. Although that breed is most closely associated with the institution, others have also had their day.

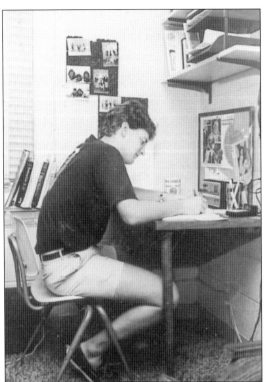

DORMITORY LIFE, LATE 1980s. An unidentified student studies in his room, probably in either Crawford Johnson Hall or J.D. Pittman Hall. Visually, dormitory life at Samford didn't change much between the late 1950s and 1980s. Construction of the Beeson Woods and West Campus Residence Halls in the 1980s and 1990s brought apartment-style living and modern furnishings.

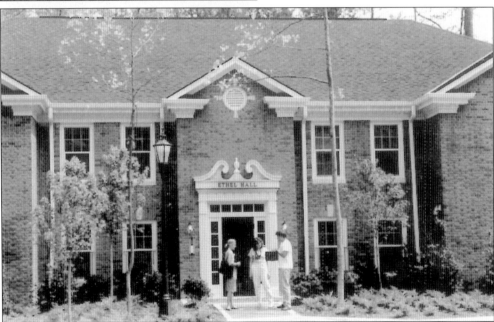

ETHEL HALL. Begun in the 1980s, the Beeson Woods residence halls have proven to be extremely popular quarters for upperclassmen. All but one of the 13 halls accommodate approximately 40 students each in 10 two-room suites. Each suite includes two bedrooms, two bathrooms, a living room, and a small kitchen area with refrigerator, sink, and cabinet space. Residents also have access to a full kitchen in the basement of each hall.

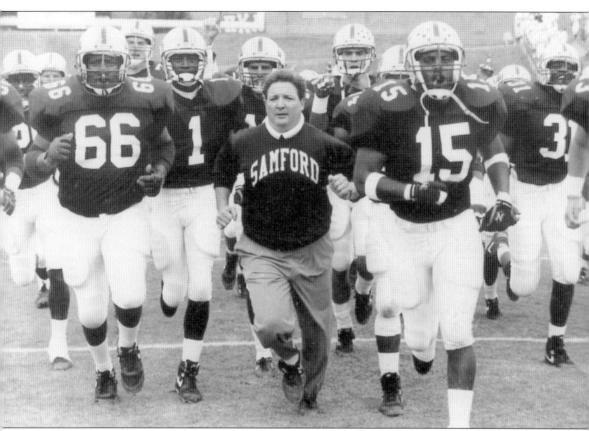

ANOTHER BOWDEN. Terry Bowden, son of legendary Howard College and Florida State University coach Bobby Bowden, became Samford's head football coach in 1987. The younger Bowden beat his father's record by leading the Bulldogs to their best season ever (12-2). His offensive coordinator? Brother Jeff Bowden.

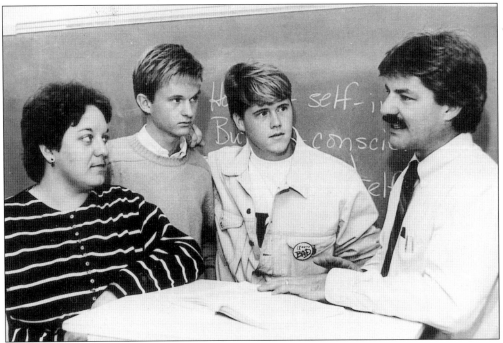

AND ANOTHER. Samford religion professor Steve Bowden, brother of Terry and Jeff Bowden, discusses something other than football with Walter Hutchens (second from left) and two unidentified students. Bowden had a winning season of his own at the time of this photograph. He received Samford's 1986–1987 John H. Buchanan Award for his outstanding teaching ability.

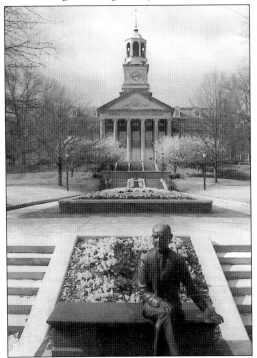

CENTENNIAL WALK. The walk, completed in 1987, commemorates Samford's 100th anniversary in Birmingham. The statue in the foreground depicting Samford benefactor Ralph Waldo Beeson was created by noted sculptor Glynn Acree.

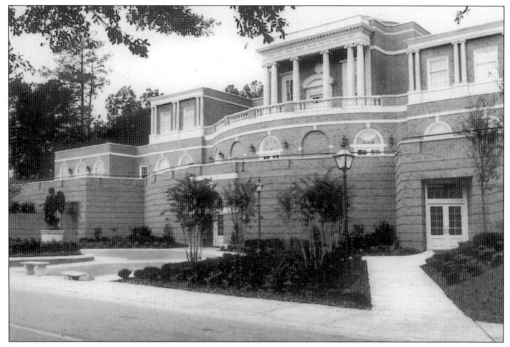

DWIGHT AND LUCILLE BEESON CENTER FOR THE HEALING ARTS. Home to Samford University's Ida V. Moffett School of Nursing, the Center for the Healing Arts was designed by Birmingham architect Neil E. Davis and dedicated in 1988.

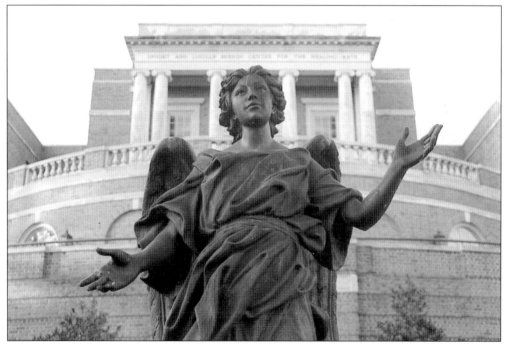

ANGEL OF MERCY. Visitors to the Center for the Healing Arts are greeted by the bronze Angel of Mercy created by former Samford student Tim Britton (known professionally as Constantine Breton) and Italian sculptor Urbano Burratti.

111

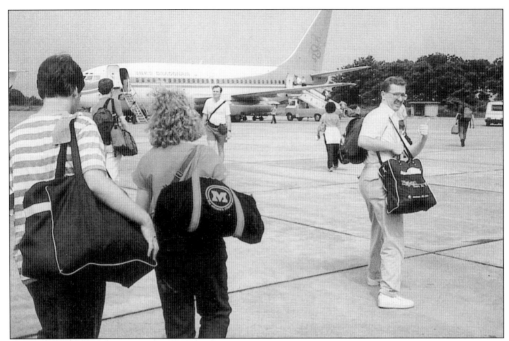

UNEXPECTED DEPARTURE, 1989. As the tragic events of the summer of 1989 unfolded in China, visiting Samford professors and students found themselves in a very uncertain and potentially dangerous situation. At home, Samford officials worked with local businessman Herbert Hsu to secure a safe exit for the group. School of Music professor Tim Banks flashes the thumbs up as the group escapes what appeared to be developing into a full-fledged coup or revolution. (Courtesy of Wanda Alexander Banks.)

WEST CAMPUS RESIDENCE HALL. Samford's West Campus Residence Halls, completed in the 1990s, are architecturally similar to the Beeson Woods Residence Halls, but include fraternity and sorority houses and offer both traditional dormitory rooms and apartment-style living. The complex currently is home to eight Greek houses, including the Phi Mu hall pictured here. Three West Campus halls serve independent students.

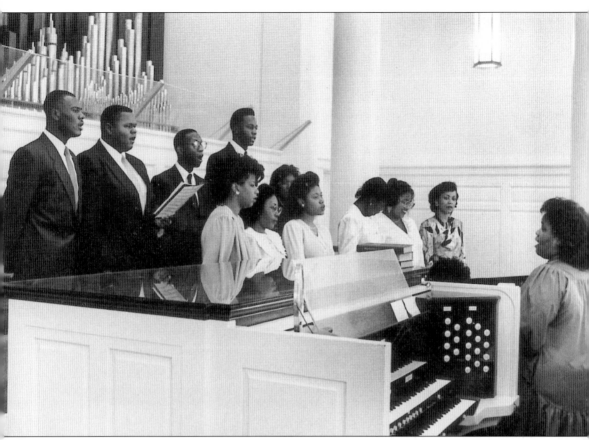

VOICES OF TRIUMPH, c. 1990. The Voices of Triumph choral group performs in Reid Chapel. The group, which grew out of Samford's Black Student Organization, sought to broaden cultural awareness by performing spirituals, gospel, and other music associated with African-American heritage. Although slow to integrate in the 1960s, by 1994 Samford University was recognized by author Erlene B. Wilson as one of the nation's "100 best colleges for African-American students."

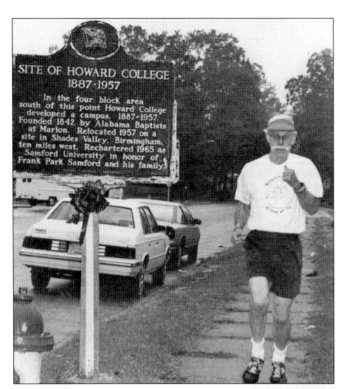

HOWARD'S COLLEGE, 1990. Howard College alumnus Howard Burton ('36) celebrates the institution's 150th anniversary by running the 10.1 miles between East Lake and the modern campus. Burton completed his journey in 3.5 hours, with enough energy left to join in Samford's homecoming festivities.

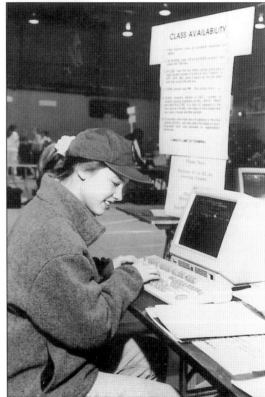

GYMNASIUM, YES—SAWDUST, NO, 1990S. Computer technology helps a student confirm her classes in Samford's Bashinsky Fieldhouse. By 2001 Samford was moving steadily towards full computer automation of registration.

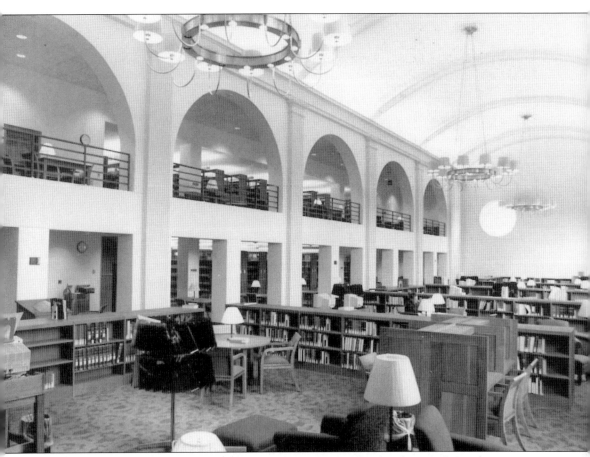

HUDNALL LIBRARY, 1993. Hudnall Library, built on the north side of Harwell Goodwin Davis Library, was named in honor of benefactors Frank and Clara Hudnall. The addition was the first stage of what was to be a $12-million renovation of Samford's library complex. Further construction in the late 1990s fully joined the new facility with the old via a majestic staircase of black Canadian granite.

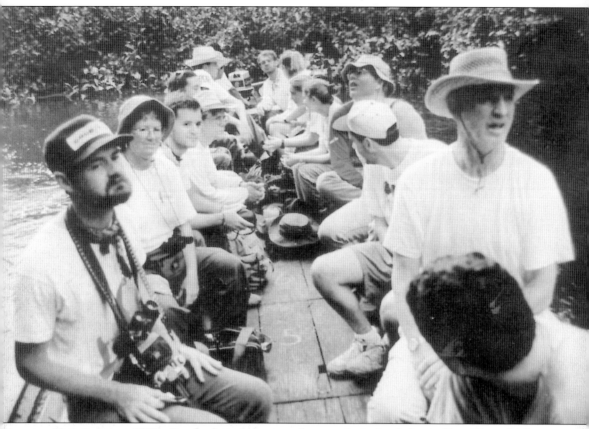

THE AMAZON, 1993. Samford students travel extensively in their studies. Here, biology professor Larry Davenport (far left) and January term students watch the trees for sloths as they navigate a black water stream in the Amazon River rain forest. In addition to biology, the students studied the culture and folklore of the region.

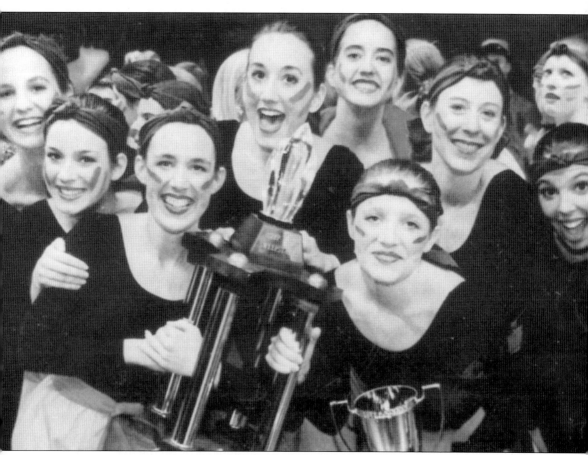

STEP SING WINNERS, 1994. The sisters of Alpha Delta Pi sorority earned their Step Sing trophies with an African-themed musical medley. Each year, between 700 and 800 Samford students—over one quarter of the total undergraduate population—participate in this unique musical tradition, which celebrated its 51st anniversary in 2001.

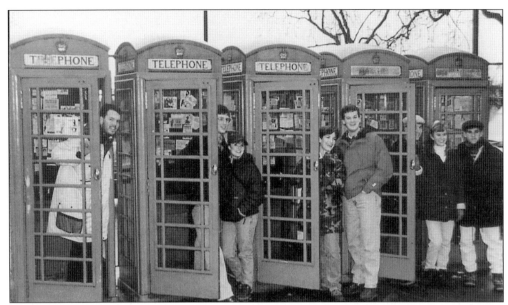

PHONE HOME, 1994. Pictured from left to right, Jonathon Roberts, William Allen, Paula Byars, Whitney McMakin, Thad Franklin, Marty Ray, Angela Stanfield, and Lee Teague pose with distinctive British telephone booths. The students were studying at Daniel House, Samford's "campus" in London's West End. The five-story Victorian family home is within easy walking distance of some of the city's most treasured landmarks, including Royal Albert Hall, the Victoria & Albert Museum, and Hyde Park. When the London program began Samford had to actively recruit students willing to spend a semester abroad. Thanks in large measure to professor Marlene Hunt Rikard's direction of the London program, students now camp out overnight to be first in line to register.

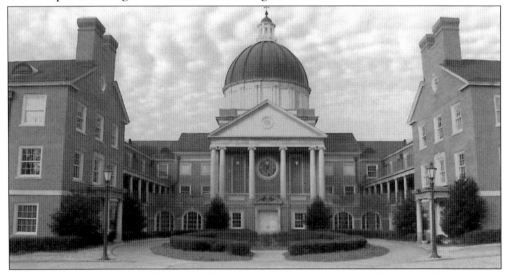

BEESON DIVINITY SCHOOL. The splendid copper dome of the Divinity School's Georgian-Colonial chapel rises above the school complex. The facility was designed by Birmingham architect Neil Davis and dedicated in 1995. Former residents of Crawford Johnson Hall (designed by Davis's father, Charles, in the 1950s) may recognize the balconies, courtyard, and wings of the Divinity School as the renovated remains of their old dormitory.

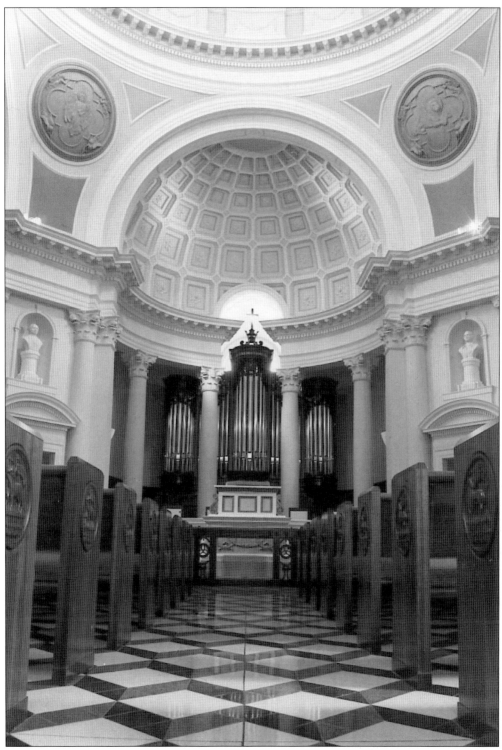

BEESON DIVINITY SCHOOL CHAPEL. The richly ornamented interior of the Divinity School's chapel features a patterned granite floor and seating for 450.

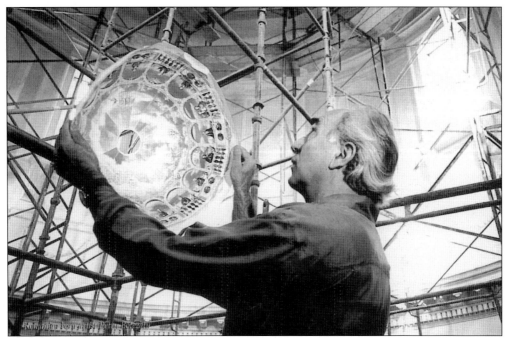

PETRU BOTEZATU IN THE BEESON DIVINITY SCHOOL CHAPEL, 1994. The Romanian-born master muralist holds a model of the chapel dome's interior, complete with miniature versions of his planned paintings. The finished work featured portraits of 16 key figures in the development of Protestantism and the Baptist faith.

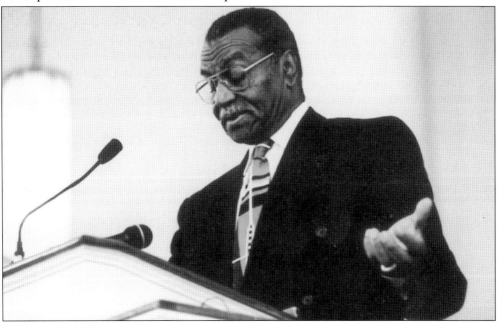

THE REVEREND FRED SHUTTLESWORTH, 1996. Fred Shuttlesworth, a founder of the Southern Christian Leadership Conference and key figure in the 1950s and 1960s civil rights campaigns in Birmingham, speaks in Reid Chapel. Shuttlesworth urged his Samford audience to use faith in the service of social justice.

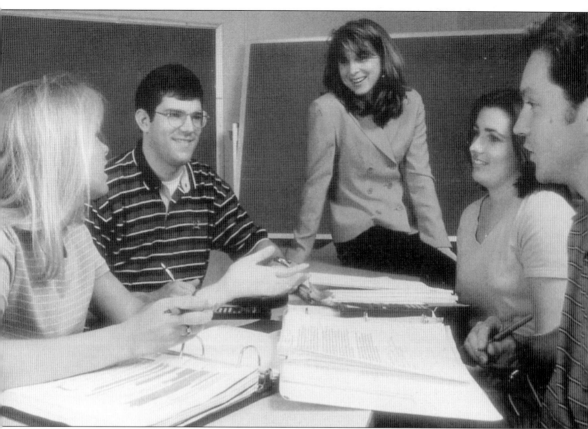

PROBLEM BASED LEARNING, 1998. Professor Pamela Sims guides students in her Therapeutic Pharmacy class. Like many Samford professors, Sims incorporates Problem Based Learning (PBL) into her courses. The innovative teaching method typically features small groups of students working to solve practical problems. Pictured from left to right are Sally Hall, Jim Wurst, Sims, Tia Bass, and Spencer Roberts. With grants from the Pew Charitable Trusts totaling $1.75 million, Samford is emerging as a leader in both PBL practice and in recognizing and promoting PBL as a valuable scholarly endeavor.

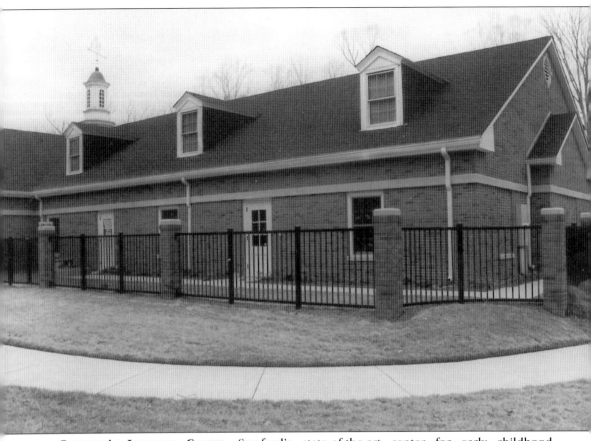

CHILDREN'S LEARNING CENTER. Samford's state-of-the-art center for early childhood education, opened in 1998, reflects the school of education's commitment to innovative and inclusive learning.

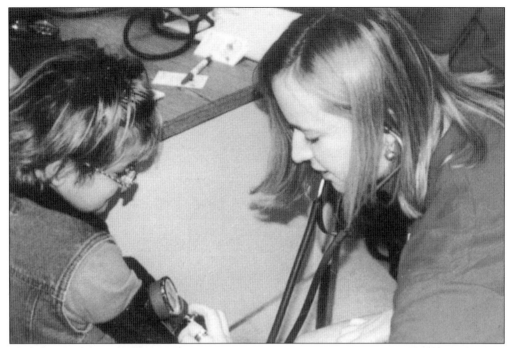

COMMUNITY SERVICE, 1999. Samford nursing student Charlea Thornton, right, reads the blood pressure of an unidentified patient at a health fair for migrant workers in Oneonta, Alabama. Samford's Ida V. Moffet School of Nursing continues to serve communities of migrant and seasonal workers through its Chandler Mountain Project, begun with a grant from the Baptist Health System.

NEW IDEAS, 1999. Biology professor Mike Howell demonstrates his teaching-photographic tank. He invented the device in response to Samford students' concerns about traditional study methods that involved the destruction of biological specimens. The tank, which immobilizes a fish without harming it, is part of a broader effort at the university to reduce the environmental toll of biological study. Included in the photograph, from left to right, are Luke Roy, Jenny Goforth, John Latimer, Kristin Farmer, and Howell.

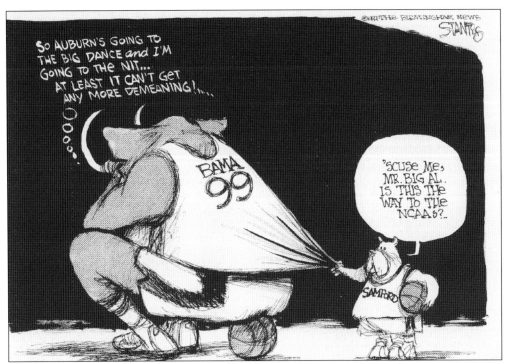

UNDERDOGS, 1999. *Birmingham News* cartoonist Scott Stantis captured the spirit of Samford's advance to its first NCAA Basketball Tournament. The team, led by Trans America Athletic Conference Coach of the Year Jimmy Tillette, won national attention for its Princeton-style offense and inspiring rise to the championship.

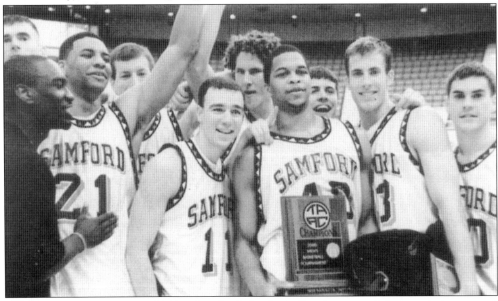

POST-GAME CELEBRATION, 2000. Samford basketball players celebrate their second consecutive Trans America Athletic Conference title. Seen here from left to right are Cornell Felton, Marc Salyers, Derrick Jones, Boyd Kaiser, Mario Lopez, Gabe Skypala, Will Daniel, Lee Burgess, Reed Rawlings, and Chris Weaver.

HABITAT FOR HUMANITY, 2000. Samford University students, faculty, and staff regularly volunteer both funds and labor to help Habitat for Humanity build affordable houses for families in need. Here, Samford University Library staff member Tabitha Moore and son Joshua take a break while working on a new house.

THE NATIONAL AWARD FOR EFFECTIVE TEACHER PREPARATION, 2000. U.S. Secretary of Education Richard Riley recognizes Samford's innovative Orlean Bullard Beeson School of Education and Professional Studies as one of the nation's premier teacher education programs. Pictured from left to right are Joe Lewis, acting provost; Thomas E. Corts, president; Ruth C. Ash, education dean; Riley; Jean A. Box, associate education dean; and Carol D. Dean, education professor.

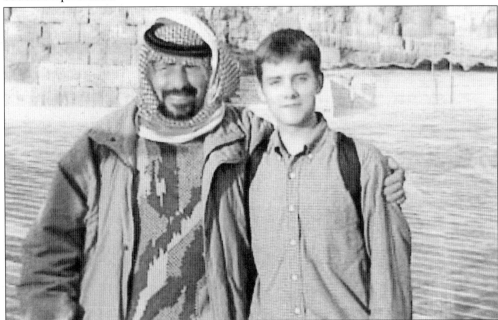

EXPANDING HORIZONS, 2001. Samford student John Anderson stands with Iraqi Christian driver Musa at Umm Qais, Jordan. Anderson was one of 13 students studying history, classics, geography, and religion in conjunction with the Jordan Evangelical Seminary during Samford's January term. Samford professors Jim Brown, Greg Jeane, Dennis Sansom, and Randy Todd led the university's first Jordanian journey. (Courtesy of Jim Brown.)

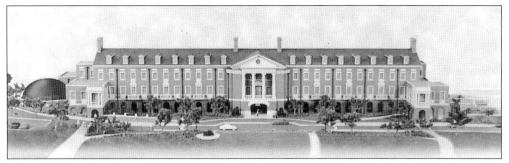

MODEL OF SAMFORD'S NEW SCIENCE CENTER. Construction is underway behind Reid Chapel for a science facility unequaled in the Southeast. In addition to housing the offices, classrooms, and laboratories of the biology, physics, and chemistry departments, the $23-million facility will include a 100-seat planetarium and a 2,000-square-foot glass-and-steel conservatory. The archway at the building's center provides access to the Beeson Woods Residence Halls. Samford University plans to unveil the new facility in the fall of 2002.

SAMFORD UNIVERSITY LIBRARY, 2000. A view of Samford University Library in late summer captures some of the lush natural beauty of Samford's modern campus. The facade of the library, virtually unchanged since the 1950s, belies the stunning interior renovation of the facility. The stairs of Samford's Centennial Walk, an addition of the late 1980s, provide a grand entrance through the university's quadrangle.

THIS BOOK, 2001. The author's research table is pictured in the University Library's Special Collection Department. The white boxes under the near end of the table contain some of photographer Lew Arnold's most prized images. At least six more boxes of photographs await review under the far end of the table. Visible atop the table are volumes of the *Entre Nous* and other publications, loose prints, a photographic copy stand, and the author's camera bag. It's all tomorrow's history, you know.